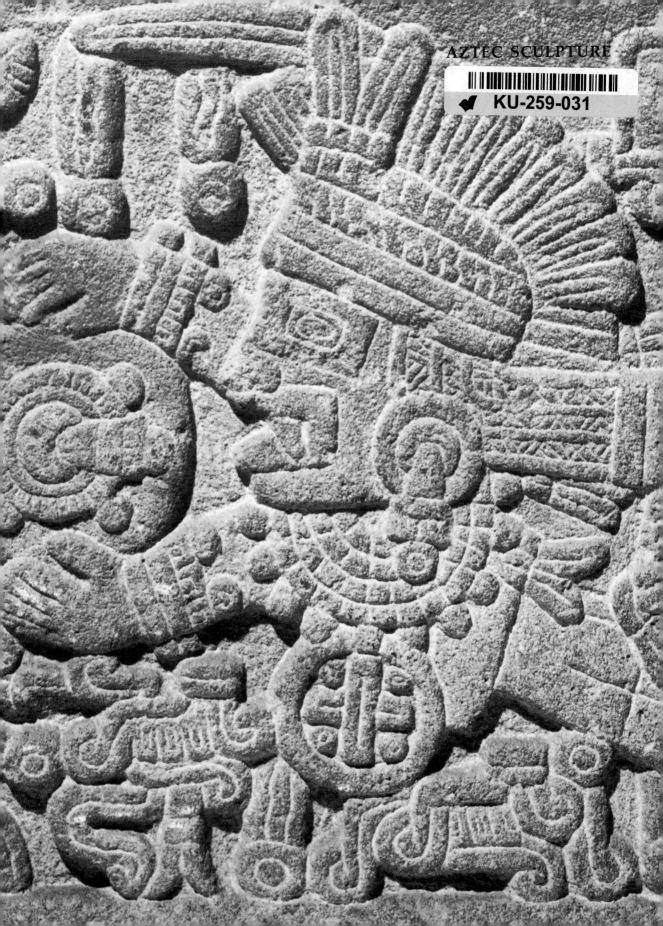

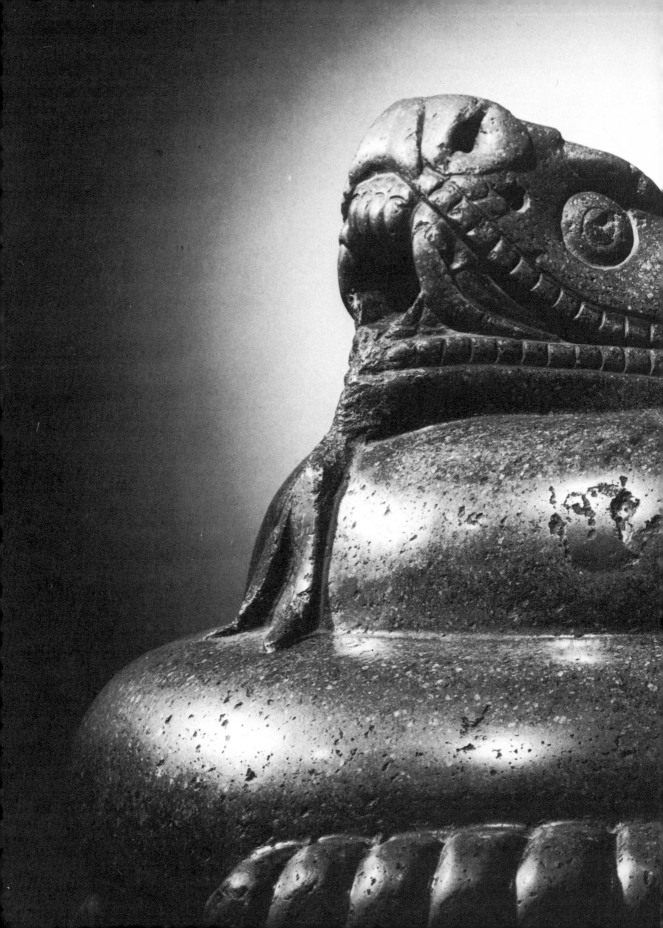

AZTEC SCULPTURE

Elizabeth Baquedano

Published for the Trustees of the British Museum by

BRITISH MUSEUM PUBLICATIONS LTD

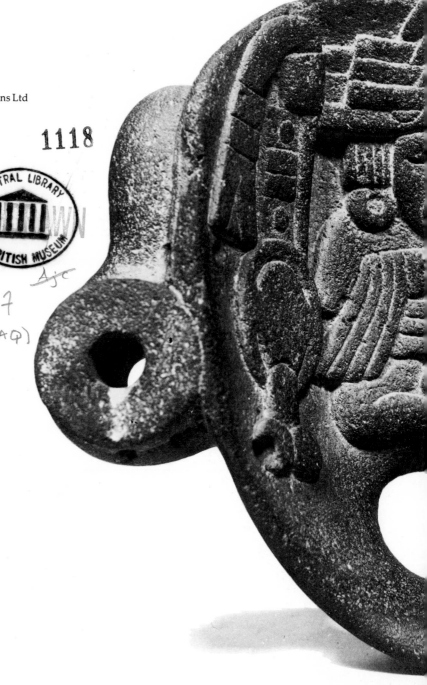

Published by British Museum Publications Ltd
46 Bloomsbury Street, London WC1B 3QQ

British Library cataloguing in
Publication Data

Baquedano, Elizabeth
 Aztec sculpture.
 1. Aztec sculpture
 I. Title
 730'.972 NB253

ISBN 0-7141-1561-4

Designed by Roger Davies
Set in Linotron Palatino by
SX Composing Ltd, Rayleigh
and printed in Great Britain by
W S Cowell Ltd, Ipswich

Acknowledgments

I would like to express my gratitude
to all those who have helped me in
the preparation of this book, and in
particular to Warwick Bray for his
unfailing help, Penny Bateman,
Elizabeth Carmichael, Margaret
Cooper, Rod Kidman, Albert Fry.
All these people were very generous
with their time and knowledge. I
owe a special debt to Carlos Monge
whose photographs were essential
in the formation of the book.

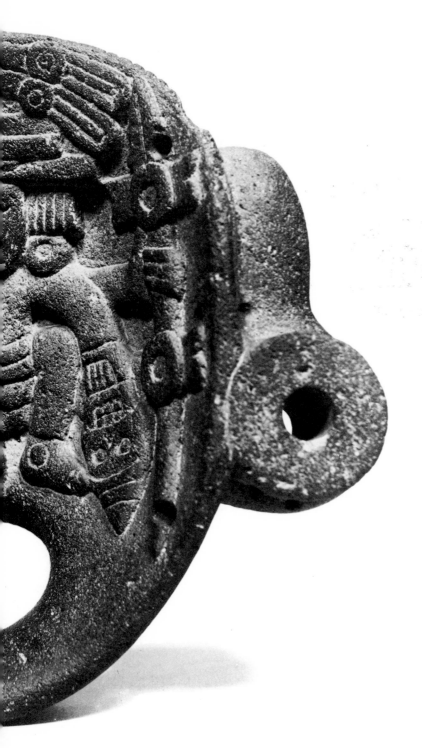

CONTENTS

Acknowledgments 4

Introduction 7

THE SCULPTURE

The Gods 25

Human Figures 59

The Animal World 69

Reliefs, vessels and boxes 81

The Rulers of Tenochtitlan and their Glyphs 92

Glossary and Index 93

List of Sculptures illustrated 95

Bibliography 96

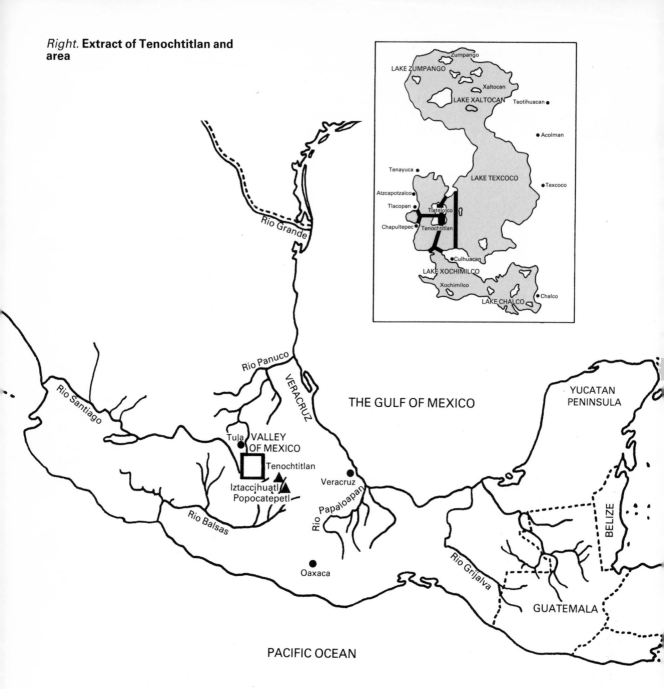

Right. **Extract of Tenochtitlan and area**

Zumpango

LAKE ZUMPANGO

Xaltocan

LAKE XALTOCAN

Teotihuacan

Acolman

Tenayuca

LAKE TEXCOCO

Atzcapotzalco

Texcoco

Tlacopan

Tlatelolco

Chapultepec

Tenochtitlan

Culhuacan

LAKE XOCHIMILCO

Xochimilco

Chalco

LAKE CHALCO

Rio Grande

Rio Santiago

Rio Panuco

VERACRUZ

THE GULF OF MEXICO

YUCATAN PENINSULA

Tula

VALLEY OF MEXICO

Tenochtitlan

Iztaccihuatl

Popocatepetl

Veracruz

Rio Papaloapan

BELIZE

Rio Balsas

Oaxaca

Rio Grijalva

GUATEMALA

PACIFIC OCEAN

General map of Mexico

Introduction

By 1519, the year in which the Spanish *Conquistadores* under the command of Hernán Cortés landed in Mexico, most of the country was dominated by the Aztec people. They had imposed political control by military force from the Atlantic to the Pacific, north at least as far as modern Veracruz and southwards to the northern Highlands of Guatemala. The capital of the Aztec Empire was Tenochtitlan ('The Place of the Fruit of the Cactus'). This great metropolis, on the site occupied by present-day Mexico City, was built on an island in the middle of Lake Texcoco, facing the snow-capped peaks of the volcanoes Popocatepetl and Iztaccihuatl to the south-east. Its grandeur amazed Cortés's soldiers, one of whom, Bernal Díaz del Castillo, wrote:

When we saw so many cities and villages built both on the water and on dry land, and this straight, level causeway, our admiration knew no bounds. It was like the enchantments in the book of Amadis, because of the high towers, cúes [temples] and other buildings, all of masonry, which rose from the water. Some of our soldiers asked if what we saw was not a dream.

The Aztecs were the cultural heirs of many earlier Mesoamerican civilisations, including that of the Olmec, who were the first people to establish major ceremonial centres, with elaborate architecture and monumental sculpture, between *c*.1250 and 400 BC. The Olmec were also apparently the first civilisation to show a preoccupation with the computation of time and the use of hieroglyphs for the recording of calendrical calculations. They also played a ritual ball-game in specially constructed ball-courts. These and other Olmec traits were to remain characteristic of Mexican civilisation up until the time of the Spanish Conquest.

During the first eight hundred years of the Christian era, commonly known to archaeologists of Middle America as the Classic period, several regional cultures can be recognised in Mexico. Amongst these, the civilisation centered at Teotihuacan ('Place of the Gods') is considered to have been the greatest in all Mexico. The site of Teotihuacan (fifty kilometres from Mexico City) still preserves some of the most impressive pre-Columbian ruins to be seen anywhere. The centre of the city was an area of palaces and flat-topped pyramids, of which the so-called 'Pyramids of the Sun and Moon' are particularly impressive. Various buildings contained representations of gods who would continue to be worshipped in Aztec times: the *tlalocs*, or rain-gods, Quetzalcoatl, the Feathered Serpent, Chalchiuhtlicue, the water-goddess, and others. In about AD 650 Teotihuacan was destroyed, but its importance as a religious centre continued until Aztec times, when Moctezuma made pilgrimages to the sacred ruins of the city.

The Classic period came to a close towards the end of the ninth century AD when most of the remaining great cities were overthrown, probably as a result of a combination of agricultural collapse caused by drought and the pressure of 'barbarians' from outer regions who were making their way into civilised Mexico. The new age is referred to as the post-Classic period. Several

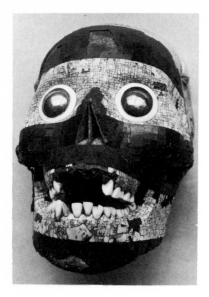

This mask is made from a human skull, set with bands of turquoise and lignite mosaic, and is thought to represent the god Tezcatlipoca. The codices show people wearing skulls like these as part of their costume; the very long leather straps attached to this mask would have enabled it to have been worn in this way.

cultures emerged during this time, all of which were predominantly militaristic in outlook. The most important of these was the Toltec civilisation, which flourished from *c.* AD 900 to 1179, bridging the gap between the culture of the Teotihuacan and that of the Aztecs.

The Toltecs established their capital at *Tollan*, or Tula, in the modern state of Hidalgo in Central Mexico. The Aztecs considered Tula as a place of dream and legend, where according to Aztec tradition the palaces were covered with gold, quetzal feathers and turquoise. When the Aztecs referred to the Toltecs they seem to have included all those highly cultured peoples who had existed in ancient times and whose spiritual heirs they considered themselves to be: 'The Toltecs were a skilful people: all of their works were good, all were exact, all were well made and admirable'. Many of these achievements were attributed to Quetzalcoatl, the god of the arts and of learning and a symbol, in this respect, of the flowering of the Toltec culture.

Historical sources tell us of the existence of a real man called Topiltzin-Quetzalcoatl, a great priest-ruler of Tula. The name, or title, Quetzalcoatl means 'Feathered Serpent' and archaeology has revealed many sculptures and temple-friezes depicting feathered serpents symbolising the deified Quetzalcoatl. It is clear that in the story of Quetzalcoatl history and legend are closely intertwined. Legend has it that Quetzalcoatl, the god, had a rival called Tezcatlipoca, god of the night and of the north, who wanted to establish the cult of militarism and human sacrifice in opposition to the benevolent Quetzalcoatl, who had taught men the skills of medicine and astronomy, as well as arts and crafts, and who demanded from the people only non-violent offerings of jade, snakes and butterflies.

Tezcatlipoca won the contest and, as a result, Quetzalcoatl is said to have left Tula in AD 987. With his followers he crossed the Valley of Mexico, passing between the volcanoes Iztaccihuatl and Popocatepetl, and continued to the Gulf of Mexico, where he set himself alight and was reborn as the Morning Star. A different historical source tells of how Quetzalcoatl and his followers set out over the sea on a raft made of serpents. He journeyed towards the east, whence, he prophesied, he would one day return. It was this legend that Moctezuma II recalled and, it seems, believed, so that when Cortés landed in Mexico in 1519 Moctezuma thought him to be the returning Quetzalcoatl.

Archaeological excavations at Tula have produced evidence for a cult of war and death; for example, sculptures called *chacmools*, reclining figures supporting round dishes which were used to receive blood and other sacrificial offerings. There are also friezes which depict jaguars devouring human hearts. The eagle and the jaguar became the emblems of the new warrior castes and there is no doubt that Tula was the centre of a new and bloody militarism. This is also evident in the *tzompantli* or 'skull-rack' sculptures, altars decorated with carvings of human skulls. These were representations of the racks actually used to display the heads of sacrificial

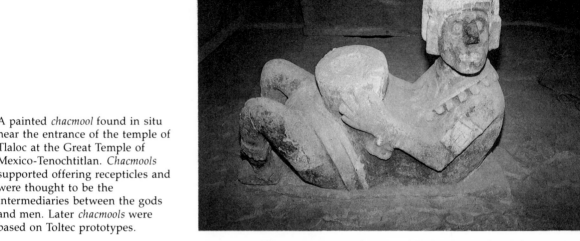

A painted *chacmool* found in situ near the entrance of the temple of Tlaloc at the Great Temple of Mexico-Tenochtitlan. *Chacmools* supported offering recepticles and were thought to be the intermediaries between the gods and men. Later *chacmools* were based on Toltec prototypes.

captives at the ceremonial centre of Tula. From the Toltec period come representations of a number of deities later worshipped by the Aztecs: the maize-goddess Chicomecoatl, Xochiquetzal (the goddess of love), and many others. The city of Tula was destroyed and abandoned in AD 1175 or 1179, but some Toltec refugees fled to the southern half of the Valley of Mexico, where they kept up the Toltec traditions.

After the collapse of the Toltecs the Valley of Mexico was invaded by newcomers from the north, the Chichimecs. The last of the Chichimec tribes to arrive in the Valley was a group of wandering peoples known as the Aztecs, or Mexica. According to some accounts, the Aztecs (the peoples of Aztlan) left their island home in AD 1111 or 1168. The location of the semi-legendary Aztlan has never been established. Some scholars have placed it as far away as the southern part of the present-day United States of America, others as near as the Valley of Mexico itself, although most sources place Aztlan somewhere in the north-west of Mexico.

The migrants were few and poor, guided by four priest-rulers, or *teomamas* ('Bearers of the God'), who carried an image of their tribal god Huitzilopochtli ('Hummingbird of the South' or 'Left-handed Hummingbird'). Their migrations lasted some two centuries before they finally settled at Mexico-Tenochtitlan. During this time the Valley of Mexico was occupied by a number of tribes forming small kingdoms, some more civilised than others. In the course of their search for a permanent homeland the Aztecs stopped at various places, but were always forced to move on. When they began their journey, the Aztecs were a semi-normadic people, but they were not entirely uncivilised. They were divided into seven clans (*calpulli*), spoke Nahuatl (the language of the civilised peoples of Central Mexico), and used the ancient ritual calendar based on a cycle of fifty-two years common to all the cultures of Mesoamerica.

During their migrations the tribe divided several times. The

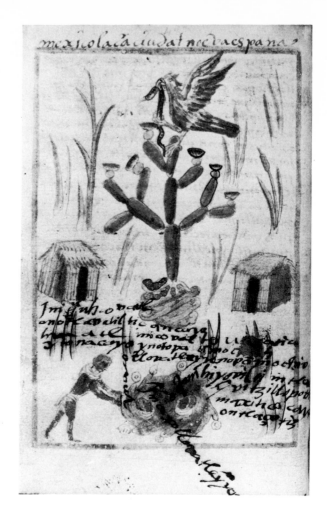

A scene from the Codex Aubin shows the foundation of Mexico-Tenochtitlan. The sight of an eagle perched on a cactus, holding a serpent in its beak, was the omen which was to reveal to the Aztecs their promised homeland.

main body journeyed towards Coatepec, near Tula, where they celebrated the first New Fire, the ceremony which symbolically concluded or 'bound up' each fifty-two year period. It was here that, according to legend, Huitzilopochtli, the god who led them throughout their migrations, was born.

After leaving Coatepec, the Aztecs came to Tula in about AD 1168. There they stopped briefly before carrying on to the city of Xaltocan, then a leading power in the Valley of Mexico. From there they moved on again, with each move approaching the place that was to be their final destination, stopping in places such as Tenayuca, occupied by Chichimecs who had settled in the Valley after the fall of the Toltecs. Shortly before AD 1300 the Aztecs arrived at Chapultepec, but they were driven out, their ruler Huiziliuitl captured and sacrificed.

After this the Aztecs became serfs of the lords of Culhuacan. In the southern part of the Valley, Culhuacan was the main centre where the remnants of Toltec culture were preserved, and daughters of the Colhua royal house were much sought in marriage by the Chichimec kings. In return for their submission the Aztecs

were given the site of Tizapan, ten kilometres to the west of Culhuacan. Tizapan was an inhospitable place, infested with snakes and vermin, but the Aztecs transformed it into a habitable land. Contacts with the Colhuas became closer, and the Aztecs became known as the Colhua-Mexica. Their courage and value as warriors brought the Aztecs some sympathy from the ruler of Culhuacan, so that when they asked for a Colhua princess as sovereign and wife for Huitzilopochtli the request was granted. However, soon afterwards the Aztecs killed and flayed the princess. As a consequence, the tribe was expelled from Tizapan, but Huitzilopochtli was said to have consoled his people with the promise that he would lead them to their permanent resting-place and put an end to their wanderings.

It was in AD 1325 or 1345 that Aztec priests recognised the signs which, according to Huitzilopochtli's prediction, would indicate their promised land: an eagle perched on a cactus, holding a serpent in its beak. At last the Aztecs had come to the place where they would be the lords, where their great capital Tenochtitlan would be built. Thirteen years later another island to the north of Tenochtitlan, Tlatelolco, was colonised and became a second Aztec town, linked to the Mexican capital by causeways built across the lake.

By AD 1367 the Aztecs were serving as mercenaries of the powerful Tepanec kingdom of Azcapotzalco. It was to the Tepanec ruler that in 1367 the Aztecs petitioned to be allowed a monarch of their own. The request was granted and Acamapichtli ('Handful of Reeds'), the son of an Aztec nobleman and a princess of Culhuacan, became the first Aztec king. Following the custom of most of the tribes of the Valley of Mexico, the king was elected, although from the start the rulers were chosen from one single family. Under Acamapichtli the Aztecs started to learn from the Tepanecs the techniques of empire-building.

The second ruler, Huitzilihuitl ('Hummingbird Feather'), initiated a policy of political alliances through marriage. His marriage to the princess Miahuaxihuitl, a daughter of a Cuernavacan lord, which made possible the import of cotton from that tropical region, is a case in point. Huitzilihuitl died in 1415 or 1416, and his son Chimalpopoca ('Smoking Shield') took over the government. His reign was a period of economic progress, and stone buildings began to replace the original reed structures of Tenochtitlan.

Tepanec dominion was not to last. In AD 1427 the Aztecs allied themselves with the Acolhua of Texcoco, and in 1430, during the reign of Itzcoatl ('Obsidian Serpent'), the fourth Aztec ruler, this alliance destroyed the Tepanec capital of Azcapotzalco. With this success the two victorious sovereigns decided to enter into an alliance with the city of Tlacopan (now called Tacuba). This 'Triple Alliance' formed the basis of the Aztec Empire. After Itzcoatl's death in 1440 the three allied cities dominated the whole of the central part of the Valley. Texcoco, under the rule of Nezahualcoyotl ('Hungry Coyote'), became the cultural and artistic centre of the Valley.

Moctezuma Ilhuicamina ('Archer of the Sky') began the great Aztec expansion. He extended the Empire to the Huastec region of the Gulf Coast, and conquered the Mixtec kingdoms of the south-west. During his reign, from around AD 1450, the area was afflicted by a terrible drought which was to last four years; as a desperate plea for the rain on which the farmers depended, many people were sacrificed to the Aztec gods. To provide the required number of victims for sacrifice to the god Huitzilopochtli, a treaty known as the 'Flowery War' was instituted between the Triple Alliance and the states of Tlaxcala and Huexotzingo. This was a ceremonial combat whose sole purpose was the capture of victims for sacrifice to the god. This war resulted in a long-standing enmity between the Aztecs and Tlaxcalans which was later to prove decisive in the Aztec struggle against the Spaniards. During Moctezuma's rule the custom of carving royal portraits became important; in order to leave a permanent record, Moctezuma had his likeness carved on the cliffs of Chapultepec ('Hill of the Locust'). The memorial, though damaged, is still visible today.

Axayacatl ('Face of Water') succeeded Moctezuma I. Although he managed to conquer Tlatelolco, killing its ruler and replacing him with an Aztec governor, he was less fortunate in his campaign against the Tarascans of Michoacan, the Aztecs' western neighbours, who defeated Axayacatl at Tlaximaloyan. The Aztecs never conquered the Tarascans. Axayacatl was succeeded by his brother Tizoc. His brief reign lasted only six years, and he was considered to be a coward in comparison with his brothers Axayacatl and Ahuitzotl, who were lovers of war. It was under Tizoc's government that the monolith known as the Tizoc stone was carved, depicting the victories of the *tlatoani* (ruler).

Ahuitzotl was the eighth king (1486-1502). He enlarged the Empire from north to south, along the coast of the Pacific as far as the Guatemalan border. He was the greatest of the empire-builders, but his reign was also remarkable for a great expansion of building, both civil and religious. He completed the main Temple of Tenochtitlan, dedicated to Huitzilopochtli and Tlaloc, in whose honour many people were sacrificed. He also built an aqueduct to bring water from Coyoacan to Tenochtitlan. During its inauguration a terrible flood occurred which, according to some accounts, led to the ruler's death. In the British Museum is a stone box decorated with symbols connected with water which seem to refer to Ahuitzotl; this box is thought by some to be his cinerary casket.

At the time of the arrival of the Spaniards in 1519 the Aztec Empire, according to native documents, was made up of thirty-eight provinces which were subject to taxation or tribute. Moctezuma II, or Moctezuma Xocoyotzin, was the last ruler before the Spanish Conquest. Son of Axayacatl and nephew of Ahuitzotl, he reigned from 1502 until 1520. He was thirty-four years old when he was elected, and like his predecessor he too was a military leader. His military expeditions added Oaxaca and adjacent regions to the Empire. One important monument built under his rule is known as

A page from the Codex Mendoza, showing Axayacatein O Axayacatl, the sixth ruler of the Aztecs. Under his reign (AD 1468-81) a total of 37 towns were added to the Aztec Empire.

the Temple of the Flowery War (El Teocalli de la Guerra Sagrada). It consists of a temple-pyramid carved in stone and is thought to represent Moctezuma's throne.

As a monarch Moctezuma was greatly feared and respected, but he was also much given to religious contemplation and philosophy. In moments of retreat he devoted himself to religion to such an extent that when the Spaniards arrived in Mexico he took Cortés to be the personification of Quetzalcoatl returning from beyond the sea to destroy the Mexican peoples, as ancient legend had predicted. Being imbued with such Toltec traditions, Moctezuma contemplated his downfall at the hands of the *Conquistadores*. At first he made little attempt to resist the Spanish invaders. He sent placatory gifts and admitted them to the city of Tenochtitlan, allowing himself to be taken hostage. In the first outbreak of hostilities, following the massacre by the Spanish of Aztecs gathered for an annual festival, Moctezuma was killed. After Moctezuma's death two more rulers attempted to govern amid the chaos. Cuitlahuac came to the throne in 1520 and during his short reign resistance to the invaders began. In the following year he was succeeded by

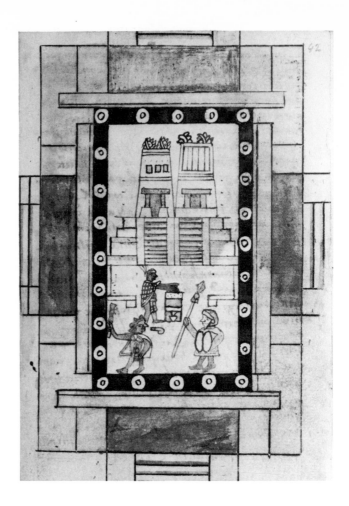

A scene from the Codex Aubin, showing the Great Temple of Tenochtitlan.

Cuauhtemoc; he witnessed, on 13 August 1521, the final victory of the Spaniards, who had increased their strength through alliances with Aztecs' rivals, including the Tlaxcalans. This defeat marked the end of Tenochtitlan and the Empire of the Aztecs, and the beginning of New Spain.

AZTEC RELIGION

Religion was fundamental to Aztec culture; its influence controlled and dominated all aspects of everyday life. From the moment of birth an Aztec child entered directly into the mysterious and magic world of religion. Throughout the whole of a person's life, till he died, religion governed every action and every event. The Aztecs felt that they were in collaboration with the gods; their lives were dedicated to maintaining the order and equilibrium of the universe, and through this collaboration mankind played an active part in the life of the gods. In the words of Jacques Soustelle (1970): 'The Aztec religion supported all of the building of the Mexican civilisation: it is not strange that, when this complex was broken by the hand of the conquerors, the entire building was left in ruins'.

Everyone participated in religion both individually (each house had its own altar) and collectively, in the festivals of the major gods. Religion permeated the whole of the Aztec world: the most important elements of life and nature were deified, and the vast Aztec pantheon contained a great variety of gods, among the most important of whom were the gods of water, of the earth, of death, of wind and of fire. Evidence of the nature of Aztec religious beliefs survives in a variety of media. Religious architecture (in the form of temples, pyramids, and so on) and religious symbolism, for example in sculpture, painting and pottery, are major sources of information. The ritual manuscripts which survive are of primary importance in understanding the priestly organisation and the cults of the individual gods.

The Aztecs conceived the world as a huge disc surrounded by water in a universe which extended outwards horizontally and vertically. The universe, to the Aztecs, was ordered according to five directions: the four cardinal points of the compass and, fifth, the central axis. The directions were fundamental to Aztec religious thought. All beings, including the gods, were associated particularly with one of the cardinal points. In the centre, at the summit of the world, were the most ancient of the gods, Ometecuhtli and Omecihuatl, the 'Lord and Lady of Duality', or 'Lord and Lady of Sustenance'. These primordial beings bore four sons, who were entrusted with the creation of all the other gods, as well as the world and the men who were to inhabit it. The sons of the divine pair were known as the four Tezcatlipocas ('Smoking Mirrors'), each characterised by a specific colour: red, blue, black and white. The Red Tezcatlipoca became known as Xipe Totec ('Our Lord the Flayed One'); the Blue Tezcatlipoca was identified with Huitzilopochtli, the tribal god of the Aztecs; the Black Tezcatlipoca was the only one to retain his name, and the White Tezcatlipoca was identified with Quetzalcoatl ('Feathered Serpent'). The four Tezcatlipocas were each also identified with one of the cardinal points. Although not all sources agree as to the assignation of the individual gods to particular directions, one version has Tezcatlipoca ruling over the north and Quetzalcoatl the west; in this account Tlaloc, the rain-god, rules the south and Chalchiuhtlicue, his consort, the east. Huitzilopochtli is also generally associated with the south, and Xipe Totec with the east.

Of the four sons of Ometecuhtli and Omecihuatl, Quetzalcoatl and Tezcalipoca, the two great rivals, were thought to be the most important in the creation of mankind. Quetzalcoatl was a benevolent god, the friend of men, while the omnipotent god of darkness, Tezcatlipoca, was master of witchcraft and black magic. Aztec mythology relates how, in the course of their struggles for the supremacy over the universe, the earth had already been created and destroyed four times. According to the Legend of the Suns, the first creation, initiating the first era of the world, took place under Tezcatlipoca ('The Black One'). The earth was inhabited by giants who lived on acorns and roots. Quetzalcoatl, unwilling to see the

universe ruled by his enemy, knocked Tezcatlipoca from the sky with his staff; however, the defeated god transformed himself into a jaguar and destroyed the earth. The second era began with Quetzalcoatl taking over Tezcatlipoca's role. Under his rule the earth was inhabited by men who ate only pine-nuts. This era was brought to an end when mankind was swept away by terrible winds sent by Tezcatlipoca; the survivors were changed into monkeys. The third era was presided over by Tlaloc, the god of rain, but Quetzalcoatl sent a terrible fire which transformed human beings into birds. During the fourth era Chalchiuhtlicue, the water-goddess ruled, but her universe was destroyed by a flood and men became fishes.

After the destruction of the fourth creation, the gods gathered at the city of Teotihuacan, where it was decided that one of the gods should sacrifice himself in order to initiate the fifth era (thought by the Aztecs to be the present age). One of the gods took the initiative, throwing himself into a huge brazier as a sacrifice, and was reborn as the sun. However, the sun would not move until the other gods also sacrificed themselves; at last the sun was set on its course. This era was known as *nahui ollin*, meaning '4 Motion' or 'the sun in motion'. The ruling god was Tonatiuh, the sun-god. Just as the four previous creations had been destroyed, so this creation, too, was doomed to destruction, this time by earthquakes. To ensure that the sun kept moving, and thus hopefully postponing the evil day, it was essential that it should receive its daily nourishment, in the form of *chalchiuitl*, human blood, the precious stuff of life.

Having created the sun, the next task was to repopulate the earth. This was entrusted to Quetzalcoatl, who went to the region of the dead to find the bones of those destroyed in the previous creations. Here he had to pass several tests set by Mictlantecuhtli, the Lord of the Dead. At last he succeeded, collecting the bones of a man and a woman, which he took to a mythical place called Tamoanchan. There the gods gathered again, and, grinding the bones in an earthen pan, Quetzalcoatl sprinkled them with his own blood and thus man was created anew. The newly created men were given the name *macehualtin*, 'the deserved (or chosen) ones'. Later this name came to signify the common man, the peasant.

Thus, because of the self-sacrifice of the gods in creating the sun, and Quetzalcoatl's sacrifice in creating man, the Aztecs felt a special relationship with their gods, and a special responsibility to maintain them through their own self-sacrifice.

THE GODS

The pantheon of the Aztecs was very extensive and included gods of other peoples which the Aztecs had adopted. Each god could be identified by particular attire, head-dress, insignia and colour. Among the foreign gods were Tlaloc, the rain-god, Quetzlacoatl and Tezcatlipoca. Huitzilopochtli, however, was the tribal god of the Aztecs, and not known elsewhere; his cult centred at Tenochtitlan

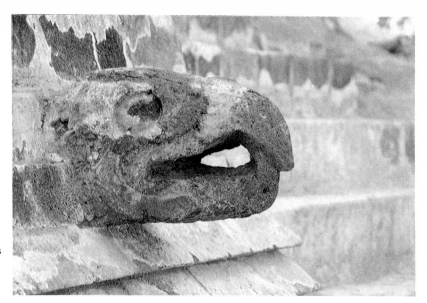

A carving of an eagle head from the Temple of the Eagles at the Great Temple at Tenochtitlan. The eagle was the symbol of Huitzilopochtli, and was closely associated with the solar cult.

and Tlatelolco. He had accompanied the Aztecs during their migrations. At first merely an obscure god of a wandering tribe, an image carried on the backs of the priests, his cult grew in importance as the power of the Aztecs grew, and thus, by the early part of the sixteenth century, he was the most important deity in the Aztec pantheon. A Spanish chronicler, Sahagún, described him: 'He was another Heracles, who was extemely robust, of great strength and warlike humour, a great destroyer of races, and killer of men . . .'

The story of his birth gives important clues to the understanding of his nature. His mother was the earth-goddess, Coatlicue. She had already borne four hundred sons, as well as a daughter called Coyolxauhqui (these offspring represented the stars and the moon). One day while sweeping the temple Coatlicue swept up a ball of feathers. She took it up and placed it in her bosom, but later when she came to look for the ball she found that it had vanished and that she had conceived another child. Her sons and daughter, instead of celebrating the event, decided to kill her so that her dishonour would not become known. However, one of her sons informed the as yet unborn Huitzilopochtli of their brothers' plans. Thus fore-warned, Huitzilopochtli decided to prepare for his birth. With the help of a fire-serpent (*xiuhcoatl*), he defeated his brothers, many of whom he killed, and beheaded Coyolxauqui, whose severed head came to rest on the slope of a hill while her body crashed below, smashing into many pieces.

From the moment of his birth Huitzilopochtli was a warrior-god. He was also a manifestation of the sun, and exemplified the sun's eternal fight against the powers of darkness, a never-ending struggle re-enacted daily. Just as Huitzilopochtli was born to combat his brothers and sister, so the sun rises each morning to do fresh battle with the stars and moon and put them to flight. To help Huitzilopochtli, as the sun, in his daily struggle, it was necessary

for man to provide the god with the most precious food that he could offer – his own life-blood. Sacrifice was considered a sacred necessity, for without the nourishment of human hearts and human blood it was thought that the sun would stop moving. Every time a priest offered the heart of a man as a sacrifice, doom was postponed once more. Huitzilopochtli enjoyed the most elevated forms of cult worship. His shrine was situated next to Tlaloc's on the main pyramid within the precinct of the Great Temple of Mexico-Tenochtitlan.

The other important gods of the Aztecs had been assimilated from other cultures, such as, for example, Quetzalcoatl. One of the creator gods and the benevolent teacher of mankind, he was also known, among his many aspects, as the god of the wind, the planet Venus and the god of twins. His associatoin with the wind places Quetzalcoatl among the gods of fertility and weather; he was said to precede the onset of rain and was supposedly the sweeper of the skies for the rain-gods. In this aspect he was known as Ehecatl and was distinguished by a conical cap and wide beak-shaped mask over his mouth. The elongated mouth may symbolise the act of blowing. Ehecatl was associated with all four cardinal points: the wind may blow from any direction. His temples were cylindrical, to offer less resistance to the wind, and rested on either square or circular platforms. As the planet Venus, which appears briefly in the morning and evening, Quetzlacoatl was both the morning and the evening star. In the latter aspect he was seen as the dog-headed monster, Xolotl. From this duality followed naturally his role as god of twins. He was considered to have invented the arts and crafts and all forms of learning and knowledge (which included the calendar and astrology). He was also the patron of the *calmecac*, the school for sons of noblemen.

Aztec religious beliefs and practises were very varied. The un-educated people believed that their lives were controlled by many divinities representing the different forces of nature; their world was populated with a variety of spirits, monsters and deities. The educated élite, however, believed that all the gods were only aspects of a single, supreme, supernatural force that was at the same time both male and female and known as Tloque Nahuaque ('Lord of Everywhere'). This tendancy to identify the different deities as aspects of one god explains why the major Aztec deities had such complex and diverse functions.

Aztec society was highly stratified, and each social class and profession had its own patron deity. Every town or village, too, worshipped its own god, often the one traditionally honoured by the people from times before Aztec rule. Among the gods worshipped by everybody were the agricultural gods, such as Tlaloc. His name means 'He who makes things grow'. He represents one of the oldest gods of fertility, not only in the Aztec world but in the whole of Mesoamerica. His cult was very important since he was responsible for the life-bringing rain on which the growth of the crops depended. Tlaloc was born of the union of a man with a

jaguar, and displays both feline and human features. He is easily recognised by the mask of twined snakes which surrounds his eyes like spectacles and by the mask over his mouth resembling a fringe of curved tusks. He also wears ear-plugs of jade, which was known to the Aztecs as *chalchiuitl* ('precious stone'). The rear part of his head-dress is a kind of fan made of paper. His clothes are usually blue or green, the colour of water. In the hierarchy of gods, Tlaloc ranked equal with Huitzilopochtli, their shrines standing side by side on top of the Great Pyramid. Tlaloc played a very important role in the life of the Aztecs. He was Lord of Tlalocan, the Paradise of the South, one of the Aztec underworlds and a land of eternal springtime. The Aztecs dedicated many ceremonies to him so that he would spare the land from drought. Although he was normally a beneficent god, if angered he could send devastating floods.

Generally, next to Tlaloc was Chalchiuhtlicue ('Lady of the Jade Skirt'), variously described as his wife, his sister, and his companion. She had jurisdiction over fresh water and, because of the importance of water in the cultivation of maize, she was closely connected with the goddesses of maize and of the earth. She commanded love, as well as fear, for if ill-disposed towards men she might sweep them to a watery death. She is usually represented squatting, her feet tucked underneath and her hands resting on her knees. Her head-dress was painted blue and white, as were the tassels that hung down at both sides of her face. Sometimes she wears a tasselled *quechquemitl*, an upper garment worn by Aztec women.

Another god of fertility was Xipe Totec ('Our Lord the Flayed One'). As a creator god identified with the Red Tezcatlipoca, he was usually painted red, or portrayed wearing red ornaments and clothes. His face, too, was painted red, with yellow bands. He is usually depicted wearing a flayed human skin. This symbolised the new life and the renewal of vegetation, the young maize breaking through the old husk. Victims were dedicated to Xipe Totec as part of agricultural rituals celebrated at the beginning of March. Xipe was also the patron of goldsmiths.

Maize was a staple food in Mexico, and thus the maize plant itself naturally became the focus of a cult, with a god of its own. Maize was represented by various deities such as Centeotl, Xilonen and Chicomecoatl. The latter was apparently the most common in the Valley of Mexico, and was the goddess of the ripe seed. Her name means 'Seven Serpent' and she is generally represented with two ears of maize, symbolising abundance. Xilonen represented the young green maize plant.

Coatlicue has been mentioned in connection with the birth of Huitzilopochtli; her name means the 'Lady of the Skirt of Serpents'. She was the earth-goddess; she wears a skirt of intertwined serpents and a belt in the form of a snake. Her breasts are always shown bare, symbolising her role as mother of the gods. Her face is generally fleshless and her hands and feet are very often depicted with claws.

Another of the agricultural gods was Xochipilli ('Prince of Flowers'), also known as Macuilxochitl ('Five Flower'). He was associated with the flowering of the maize plant, but was also the god of pleasure in all its forms: love, dancing, music and games. His characteristic emblem is an ornament in the shape of a comb that reaches from his forehead to the nape of his neck. His attire also includes a hat decorated with feathers and a collar set with green stones, and he wears distinctive tassels on his chest, a red-edged loin-cloth and sandals decorated with flowers. He is usually painted red. A symbol of summer, Xochipilli was blessed with eternal youth.

Xiuhtecuhtli, the fire-god, was greatly revered in the Mexican Empire. He was a very ancient god and was known in different parts of Mexico under various names: 'The fire obviously identified with life-giving warmth, the vivifying principle'. The Lord of Fire was present in every home. A figure of the god in the British Museum (24) shows the characteristic circles on his head-dress which represent fire; the top of the head is hollowed out to accommodate a small fire. The burning of sacred fires, which were maintained by the priests at every shrine and temple, was associated with the cult of the sun. One of the most important Aztec ceremonies was that of the New Fire. This festival occurred once every fifty-two years. The Aztecs believed that the destruction of the earth would come at the end of one of the cycles of fifty-two years (*xiuhmolpilli*, 'bundle of years') on which the ancient ritual calendar was based. At sunset on the day of doom the sun would be destroyed by the forces of darkness and night, never to rise again. The end of each *xiuhmolpilli* was, therefore, a time of great anxiety, for no-one knew whether the sun would return. On the last day of the cycle all fires were extinguished and at nightfall the priests gathered on a hilltop to await the dawn. As the star Aldebaran reached the zenith of the sky and it became clear that the universe was saved once more, the priests could kindle a new fire from which all the fires in the temples and the houses would be lit to welcome the new day and a new *xiuhmolpilli*.

AZTEC ART

The Aztecs did not have a term for art as such. In fact, they had no notion of art for art's sake. Artists, though well regarded as a class, were subordinate to the priest and were given little scope for creative imagination. Their skills were bent in glorifying the gods and the rulers and in communicating religious ideas by visual means to a largely illiterate populace. Thus, as with all other aspects of Aztec culture, art was governed by religion, and indeed, it played a very important part in religious life. Training in the arts was considered desirable in the members of the ruling élite.

The Aztecs greatly admired fine craftsmanship, and the *Conquistadores* were much impressed by the glittering splendour of the precious metalwork and jewellery, the exquisite textiles and elaborate featherwork, and the brilliant paintings that adorned the

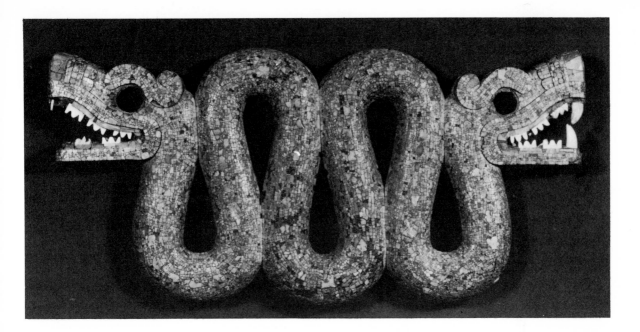

A mosaic plaque, beautifully decorated with fine turquoise mosaic work, in the form of a double-headed serpent. This plaque was probably used as a breast ornament, and is an example of the skilled craftsmanship so admired by the Aztecs. Much of the fine quality gold and lapidary work was probably produced by Mixtec craftsmen.

temples and palaces. The Aztecs employed the skills of foreign artisans, and much of the fine gold and lapidary work is thought to have been executed by Mixtec craftsmen.

These god-given skills (supposedly taught to men by Quetzalcoatl) were thought to have been preserved by survivors of the Toltec culture, and, in fact, the term *tolteca* referred collectively to goldsmiths, lapidaries and those skilled in featherwork. The skills of these craftsmen were largely exercised in the production of luxury items of jewellery and ornament for the upper classes, as well as in making objects to decorate statues in the temples. Gold and silver was used for jewellery and trinkets, and the magnificent feathers of tropical birds were used for making head-dresses, costumes and capes, and for decorating shields, helmets and so on, worn by those of high rank and used for ritual purposes. A wide range of articles, from ear-plugs to sculpture, was produced by the lapidaries working with precious gemstones.

The Spanish missionary, Bernardino de Sahagún, recorded what his Aztec informants held to be the essential qualities of a lapidary:

The lapidary is well reared, well advised; a councelor, informed in his art; an abrader, a polisher; one who works with sand; who glues mosaic with thick glue, works with abrasive sand, rubs stones with fine cane, makes them shine. He makes them shine.

The good lapidary is a creator of works of skill. He is adroit, a designer of works of skill, a gluer of mosaics of stone. They are glued. He creates, he designs works of skill. He grinds down, he polishes, he applies abrasive sand to stones, cuts them into triangles, forms designs of them.

The bad lapidary is one who scrapes the stones, who roughens them; who raises a clattering din. He is stupid bird-like. He scrapes the stone; roughens, shatters, pulverizes, ruins, damages them; raises a clattering din. (Fray Bernardino de Sahagún, Florentine Codex, Book 10, p.26)

21

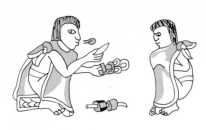

Craftsmen passed their skills on to their sons, who would take up their trade on reaching manhood. This detail from the Codex Mendoza shows a stone-cutter. The Aztecs believed that the arts of the goldsmith and the lapidary originated from the Toltecs, who had received their skills from Quetzalcoatl.

It seems incredible today that the Mexican sculptors and lapidaries could produce works of such beauty and accomplishment without the aid of metal tools. Although the use of metal was fairly common by *c.* AD 900 or 1000 (copper or bronze axes, celts and needles were in common use), the stone-workers preferred to continue using their traditional tools of wood, stone and bone. Stone picks and hammers were normally employed to quarry the raw material. The form of the sculpture was roughed out by hammering, and the final finish was achieved by fine flaking, pecking and polishing of the surface. An abrasive, usually sand and water, was used in scraping, grinding, sawing and drilling operations. Saws were made of stone, wood, fibre, bone or rawhide, while tubular drills were made of bird-bones. The drills would be used, for example, for hollowing out eyes or mouths; the cylindrical cores which resulted from the drilling would be broken off and the cavities smoothed out.

The most common materials used by the lapidaries were jade, jadeite and other green stones, turquoise and cornelian, as well as obsidian and rock-crystal. Each of these materials had its own particular qualities and properties which determined the manner of its working and the use to which it would be put. Obsidian, a natural volcanic glass, is found in several areas of Mexico and was widely used. Blades and flakes chipped from an obsidian core have razor-like edges, and they were used as knives and cutting tools. Obsidian could also be ground and polished to produce mirrors for cosmetic and ritual purposes. Masks and ear-rings were also made from polished obsidian. The Aztecs called this material *itztli*, or 'divine stone', and it was deified as the god Tezcatlipoca, whose name means 'Smoking Mirror'.

Jade was the stone most highly prized by all the Mesoamerican peoples, and so it is natural that this stone was used in the most intricate carvings. The Nahuatl name for jade was *chalchiuitl*, which means 'precious stone'. The ancient Mexicans considered it even more precious than gold, and Moctezuma's words when making a presentation of jade to Cortés are very revealing: 'I will give you some very valuable stones which you will send to him [Charles V, King of Spain] in my name; they are *chalchiuitls* and are not to be given to anyone else but to him, your great Prince. Each stone is worth two loads of gold.' Bernal Díaz del Castillo also reports that he was able to save his life several times with a few jade beads. According to legend, Quetzalcoatl had a house entirely covered with jade, and although merely a myth, this tale does show very clearly how valuable jade was considered to be. Jade was used for a variety of objects; axes and chisels made of jade were used to work softer stone; ear-pendants and necklaces were made for members of the nobility and as ornaments for the statues of the important gods.

Rock-crystal is somewhat more difficult to work than other materials because of its extreme hardness. The Aztecs, however, were very fond of this stone and found its appearance pleasing. A fine example worked in this material is the crystal skull, now in the British Museum (37).

Techniques of sculpture in Mexico have their origins in a long tradition of modelling clay into figurines of gods and humans. The subjects worked in stone are also found in a variety of other media: wood-carving, goldwork, the carving of precious gems, featherwork, pottery and even dough. The materials used in sculpture varied from jade and crystal for small-scale works to the hard igneous rocks such as basalt for the larger sculptures. (Basalt was also used for making such domestic equipment as grinding-stones and so on.) As this stone could not be given a high finish, the sculptures would be covered in plaster, polished and painted. The use of colour performed a very important function in Aztec art, and buildings as well as sculptures were painted in bright colours. Each colour had a special significance and the deities represented in the sculpture were often identifiable by the colours in which they were painted. The sculptures range from the miniature to the monumental in scale. The sculptors worked both in low relief and in the round, and often the two styles are inseparable, as statues commonly included scenes or symbols carved in relief. Although capable of a high degree of realism, Aztec art was largely symbolic rather than representational.

Little remains of the artistic achievements of the Aztecs today. Many objects of precious metal and jewels were removed and later lost or destroyed. Much was deliberately destroyed by the Spaniards in their attempts to stamp out the pagan cults, and a great deal of what was left has deteriorated through the course of time. The most durable products of Aztec art are the sculptures, which survive in considerable numbers. Here the skill of the Aztec craftsmen can be seen at its height. Their style was powerful and expressive, they were able to achieve a remarkable range of effects – from abstract subjects of great intricacy and the realistic and intimate portrayal of human beings to the dramatic and, to European eyes, terrifying representations of the gods.

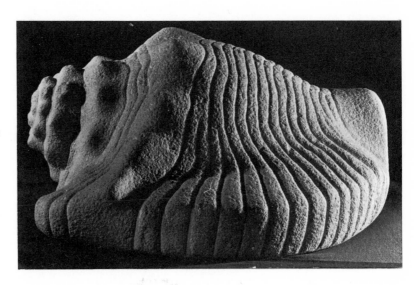

This carving of a conch shell, a fine example of the skills of the Mexican craftsmen, was found near the great temple pyramid at Tenochtitlan. The Aztecs were fascinated by the natural world, and many of the surviving sculptures show their determination to achieve a high degree of realism. Conch shells were seen as symbols of life and fertility among the Mesoamerican peoples. L 87 cm; W 74.5 cm.

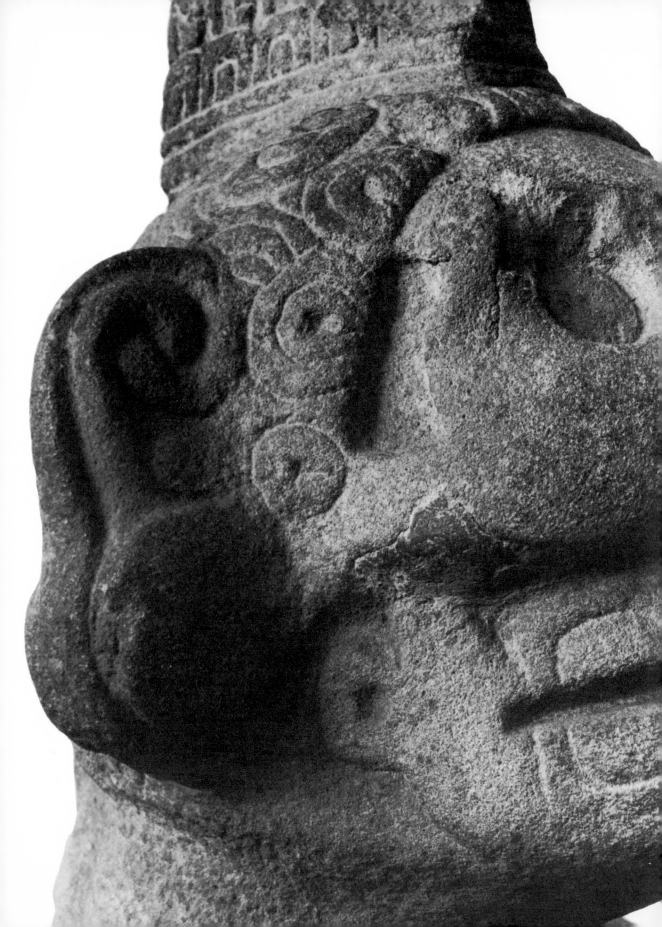

THE GODS

Sculptures of the gods were an important aspect of Aztec religious expression. Statues were placed before altars – essential features of every Aztec household – and were made to adorn shrines and temples or to be set up in the open air. Thus the people were constantly aware of the forces which governed the universe and their lives. The gods could be recognised by the symbols which covered the sculptures, by their distinctive attire and regalia, and by the colours that they were painted. Certain attributes might be characteristic of a number of different gods or groups of gods; thus the gods of water and vegetation were frequently shown wearing the same kind of head-dress; for Chicomecoatl it would be painted red (12), and for Chalchiuhtlicue blue (5). One of the reasons why it is often difficult to make a precise identification of many of these sculptures is that the original colouring, which can distinguish one deity from another, has largely vanished.

The sculptures illustrated here represent some of the oldest and most important deities in pre-Columbian Mexico, some of them having their origin in the earliest Mesoamerican cultures.

Quetzalcoatl

Quetzalcoatl had a wide range of associations in Aztec religion. One of the four creator gods, he was, among other things, the wind-god Ehecatl, the god of learning and crafts, and the god of twins; he was also identified with the planet Venus. Symbolised as the Feathered Serpent, he is often portrayed rising from the jaws of this mythical creature, representing the morning star. His name means 'feathered', or 'plumed serpent', but also 'precious twin' (*quetzalli* = 'feathers', but also 'precious'; *coatl* = 'serpent' or 'twin'). Quetzalcoatl was also an important semi-mythological figure, a Toltec priest-ruler, forced to flee to the Gulf Coast after a dispute with his rival Tezcatlipoca, but promising to return in the future and topple Tezcatlipoca from his position of supremacy. He was associated with the divine right of the Aztec rulers, who traced their descent from the Toltec royal line (and thus, supposedly, indirectly from Quetzalcoatl).

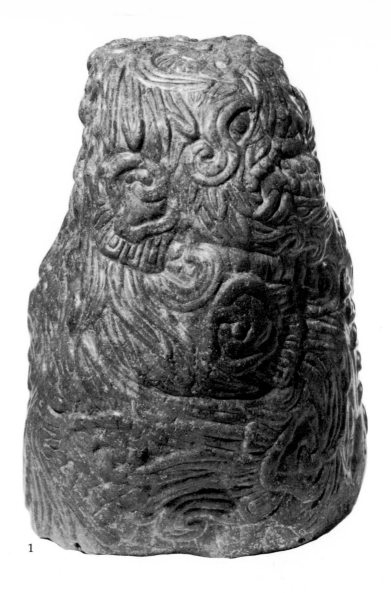

1

1. This carved figure represents Quetzalcoatl rising from the jaws of the Feathered Serpent. He wears a head-dress made of the feathers of the quetzal – a tropical bird, native to Central America; its brilliant green feathers were much prized by the Aztecs and were used as marks of honour and decorated the garments of the nobles. The curved ear-rings shown here represent shell-pendants and are characteristic attributes. Quetzalcoatl is often portrayed carrying a club, a symbol of authority, but in this sculpture he holds a rattlesnake in his right hand, and a skull in his left. His eyes were probably set with precious stones, but these are now missing. The sculpture is carved from jade, for the Aztecs the most precious of stones.
H 33 cm; jade

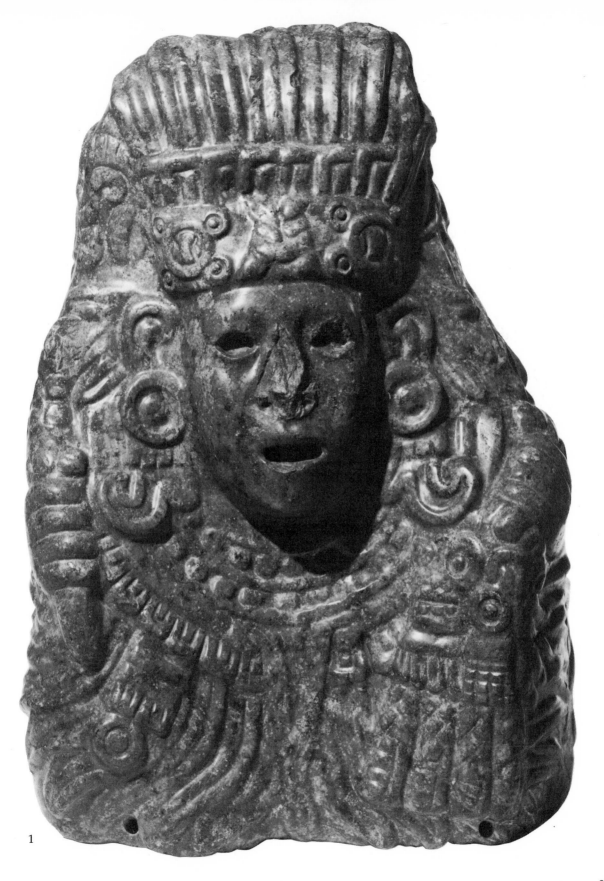

1

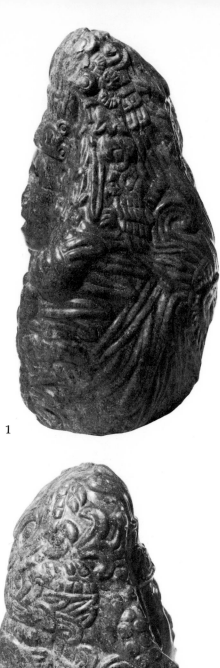

1

1

1. *Above* This enlarged detail of the figure of Quetzalcoatl shows the skull held in his left hand – the emblem of his twin deity, the malevalent dog-headed Xolotl.

1. *Right* In the view from the right the rattle on the snake's tail is clearly visible.

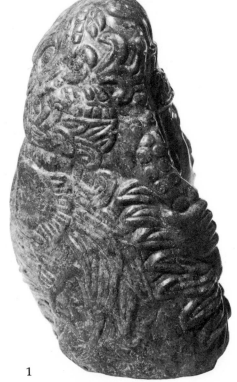

1

Ehecatl

One of the most important aspects of Quetzalcoatl, and one that affected most closely the lives of the Aztecs, was the wind-god Ehecatl. In this form the god was associated with the most elemental forces of life, for the wind was felt to contain the breath of life itself.

2. Standing figure of the wind-god Ehecatl (his name means 'wind' in Nahuatl). 'The sweeper of the skies', Ehecatl was supposed to preceed the onset of rain and was thus associated with the gods of fertility. The distinctive beak-shaped mouth and conical hat identify this sculpture as Ehecatl. H 38 cm; basalt

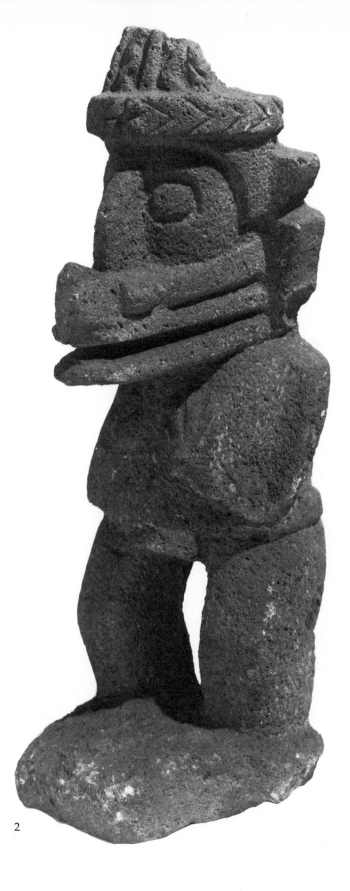

2

3. The arrangement of the hair into a spiral cone on this mask is faintly reminiscent of depictions of Ehecatl-Quetzalcoatl, and this carving is possible intended to represent this god. H 22 cm; granite

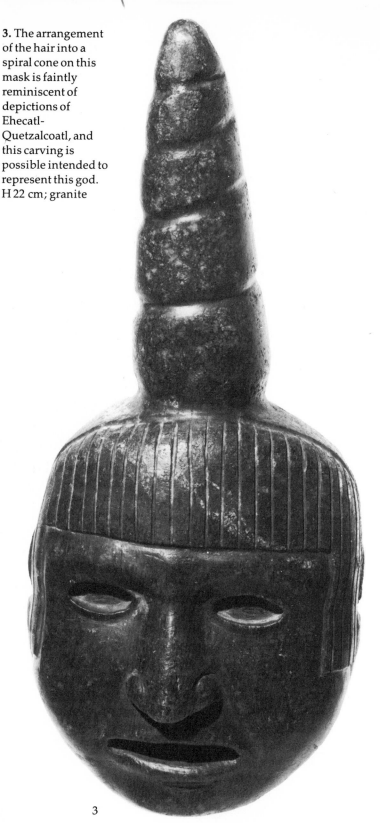

3

Tlaloc

The large number of surviving statues of Tlaloc testify to the importance of this god, one of the most ancient in Mesoamerica. Water is a natural preoccupation in any agrarian culture in a land of low average rainfall, especially where, as in Mexico, there was no system of irrigation. Tlaloc was the god of all water, from whatever source. He was generally thought of as a benificent god, for life itself depended upon the rain he brought. But too much rain, in the wrong season, can be as disastrous as drought and the Aztecs were aware of the constant need to propitiate this god with worship and sacrifice. In the hierarchy of the gods, Tlaloc ranked equal with Huitzilopochtli.

Tlaloc was the lord of Tlalocan, the watery Paradise of the South. It was a place of abundance and fertility, and of eternal springtime, the abode of the souls of those who had drowned or died from dropsy (or other water-related diseases).

4. A head of the rain-god Tlaloc, probably a fragment from a larger sculpture. This head is easily recognised as Tlaloc by the coiled snakes which form a mask round his eyes and mouth and by his curved fangs. His characteristic attire consists of a pleated paper fan worn at the back of the head (*amacalli*, 'house of paper'), ear-plugs and a head-dress set with precious stones which, in this case, represent water.
H 22 cm; basalt

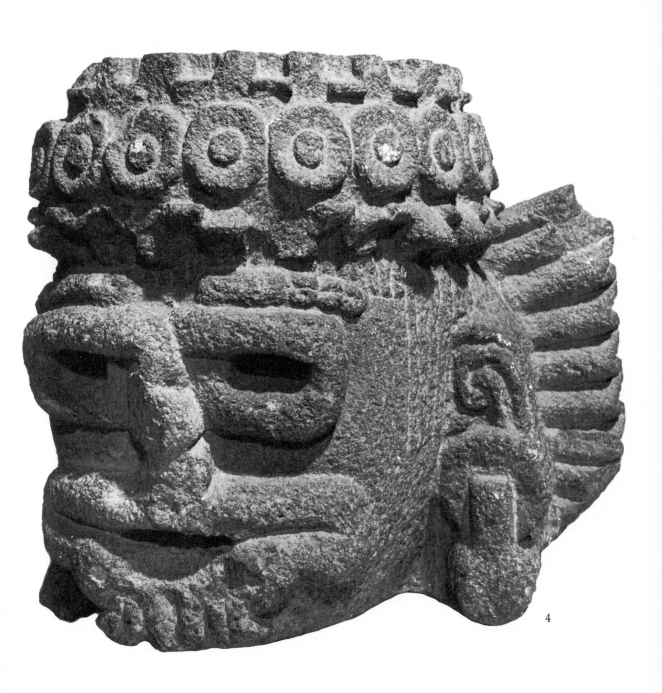

4

Chalchiuhtlicue

Chalchiuhtlicue was closely associated with Tlaloc, and was variously described in the sources as his wife, his sister or his mother. The goddess of fresh water, she ruled over rivers and lakes, and was the patron of fishermen and all who made their living from water. Like Tlaloc, she could be unreliable and dangerous if angered.

Chalchiuhtlicue is portrayed as a youthful figure. She has a characteristic head-dress consisting of three bands tied at the back of the head and fringed top and bottom with disks representing amaranth seeds (amaranth was an important constituent of the Mesoamerican diet, providing protein); a large tassel hangs down at each side of her face. She is also often shown wearing a paper fan, usually painted blue. Green jade ornaments are often shown decorating her skirt and symbolise water: one of the translations of her name is 'Lady of the Jade Skirt' (*chalchiuitl* = 'jade', 'precious stone'; *cueitl* = 'skirt'); she is also called 'Lady Precious Green'.

The attributes of the water-goddess are also frequently shared by other fertility deities, such as the maize-goddess (see 18-21), and a definite identification of the figure represented is not always possible.

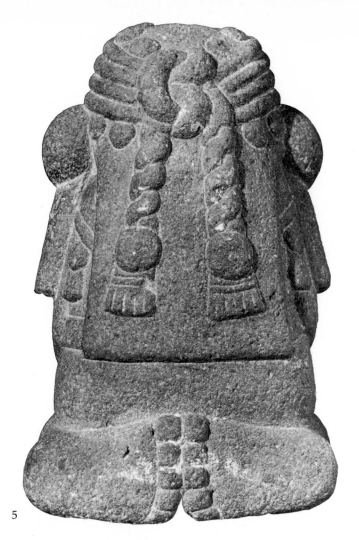

5

5. Kneeling figure of Chalchiuhtlicue. In common with many carvings of female deities Chalchiuhtlicue is shown in the pose typical of Indian women, squatting on her heels with her hands resting on her knees. She wears the characteristic head-band, with two large tassels. Statues of Aztec deities can sometimes give information about the dress of ordinary men and women. The basic costume of Aztec women was a long wrap-round skirt, over which was worn a simple upper garment, a closed shoulder-cape called the *quechquemitl*. In this sculpture Chalchiuhtlicue wears a tasselled *quechquemitl* over a skirt.

The rear view (*above*) shows clearly the headgear and the hairstyle, with two plaits hanging down below the three bands of the head-dress. The hairstyle was that typically worn by Aztec women: long, usually hanging loose, but on festive occasions braided, with ribbons, as here. A more elaborate style involved winding two plaits around the head, leaving the ends projecting like horns. Hairstyles in the stratified society of pre-Hispanic Mexico were, like clothes, an indication of status.
H 28 cm; basalt

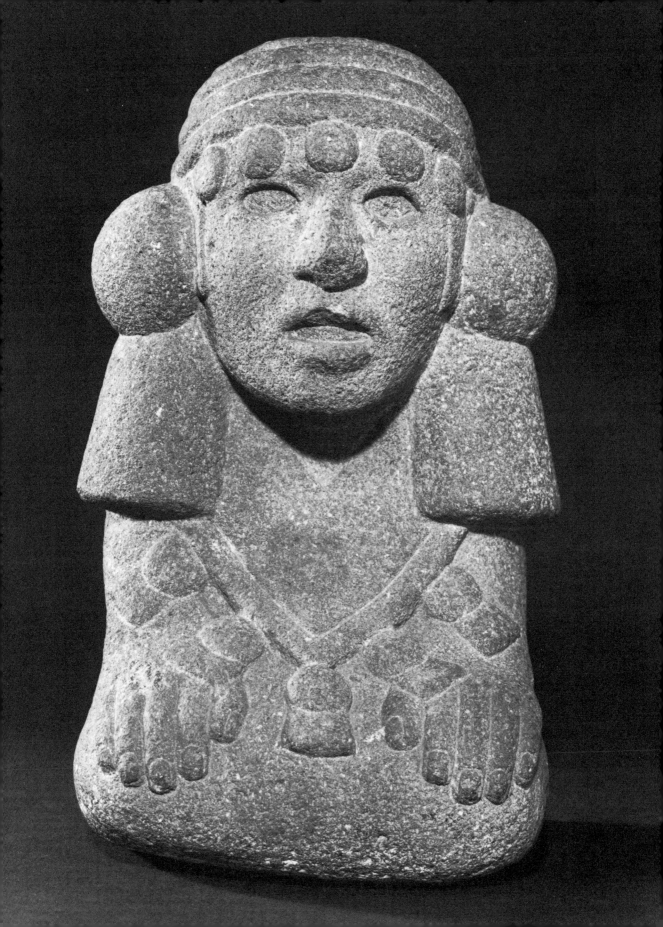

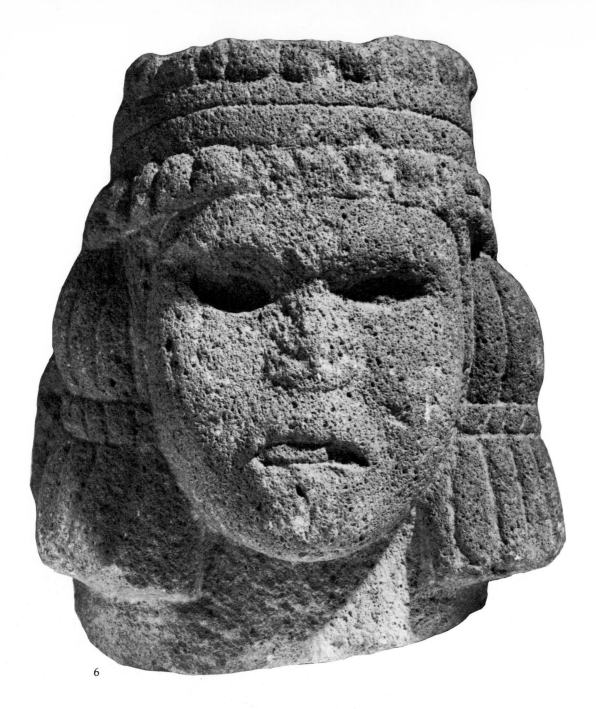

6

6. A female head, a fragment from a larger sculpture. Although the identification of this piece cannot be certain, the head-dress – a ribbon tied at the back and bordered with disks, and two tassels – is typical for the water-goddess. The sculptures of deities reflected the costumes worn at festivals and all religious ceremonies; Spanish chroniclers of the first half of the sixteenth century mention the wearing of cotton tassels.
H 23 cm; basalt

Xipe Totec

Xipe Totec, one of the four creator gods and identified with the Red Tezcatlipoca, was a fertility deity, the god of spring and new growth. The ritual practice in which priests of his cult arrayed themselves in the skins of sacrificial victims was symbolic of the regeneration of vegetation each spring. This god is connected particularly with suffering and sacrificial self-multilation. He was also the patron of goldsmiths and jewellers, and the deity of the spring rain.

Xipe Totec is often portrayed wearing a flayed human skin, the face round and bloated, the mouth hanging open and the eyes closed, signifying death.

7. Mask of Xipe Totec. This carving represents the god of spring wearing a flayed skin. Many masks survive; they were made from Olmec times up to the Colonial era and, indeed, are still made in Modern Mexico. The masks functioned as impersonators of Xipe Totec, and it has sometimes been said that they were placed over the faces of the dead.
H 22.8 cm; diorite

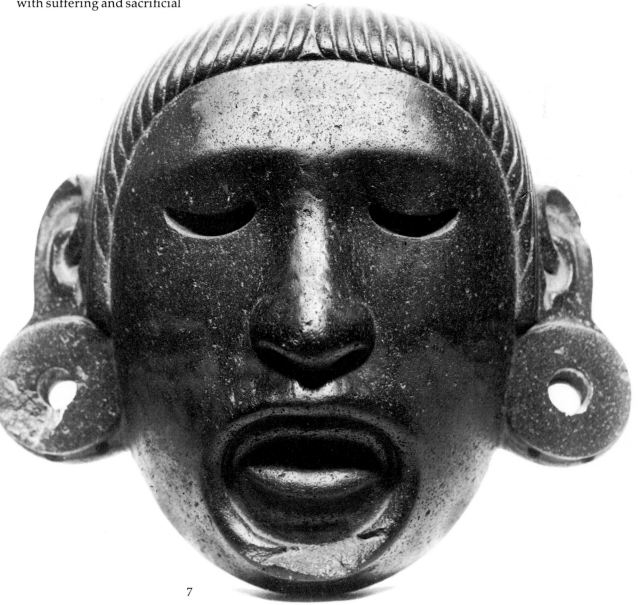

7

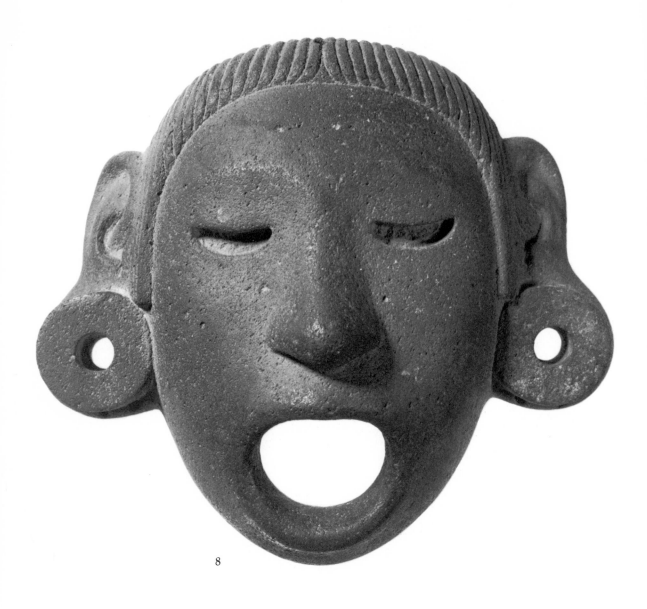

8

8. Mask of Xipe Totec. Similarities of technique and decoration between this mask and 7 on the previous page – especially the low-relief carving on the inside of both masks – suggest that they were executed by the same artist. In both, holes have been carved in the ear-lobes for the insertion of decorative plugs.

There are still traces of red pigment, the colour particularly associated with this god.

H 22.8 cm; diorite

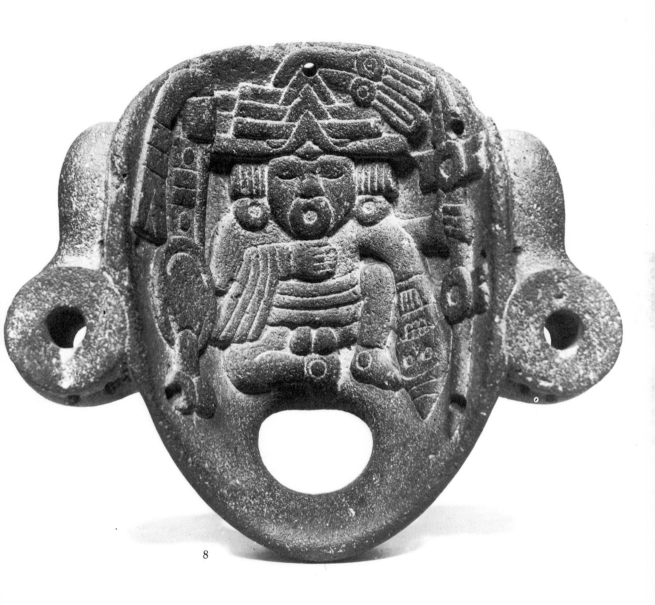

8

8. On the inside of the mask is a low-relief carving showing a priest attired as Xipe with all his attributes. He wears an ornate conical head-dress characteristic of the god, and carries a rattle stick and a stone dagger bearing the features of a human skull.

There is a similar carving on the inside of 7.

Chicomecoatl

As Aztec culture was essentially agrarian, elaborate cults concerned with fertility and vegetation developed, and many plants were personified as deities. One of the staple foods of the Aztecs was maize, and several maize deities were worshipped. The overall god of maize, Centeotl, was male, but the maize seed itself was thought of as female. The development of the plant was broken down into various stages of growth, each represented by a goddess. The young green maize was personified by the demure and youthful goddess Xilonen. Chicomecoatl, described by the Spanish as the 'Goddess of Sustenance', was the goddess of the ripe maize and was venerated at harvest-time. Her name meant 'Seven Serpent', also an esoteric name for maize (the 'serpent' element of the name is very significant, as the snake was an important fertility symbol; see 39-43). She was often represented holding cobs of maize; indeed, double-maize cobs were an attribute of fertility goddesses in general. Chicomecoatl can usually be recognised by her distinctive rectangular head-dress.

The cult of the maize goddess was very important in Aztec society. The most abundant representations in Aztec art are related to agriculture. There are sculptures of the triad of maize deities – Xilonen, Chicomecoatl and Centeotl – but more remain of Chicomecoatl than of any other fertility deity. They were

usually painted red, and varied widely in size and in the quality of the craftsmanship; the statues were placed in shrines as well as at domestic altars.

In some cases it is not clear whether the sculptures represent Chicomecoatl or the water-goddess Chalchiuhtlicue, because of some common attributes shared by fertility deities; the figures illustrated in the following pages, however, are all thought to represent Chicomecoatl.

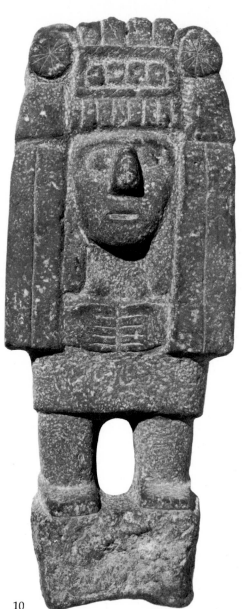

10

9. *Right* Standing figure, possibly of Chicomecoatl. This and the following sculptures (10-17) all wear the distinctive rectangular paper head-dress decorated with streamers and rosettes characteristic of the maize-goddess. The great number of such sculptures found throughout the Valley of Mexico, and the variable quality of the work, suggest that they were mass-produced.

In this example the goddess wears the typical skirt of the Aztec woman; although many of the female deities are depicted wearing the costume of Aztec women – long skirt and an upper garment – some of the agricultural deities, as here, are shown bare-breasted, symbolising fertility and abundance.
H 53 cm; basalt

10. Standing figure, possibly of Chicomecoatl
H 63 cm; basalt

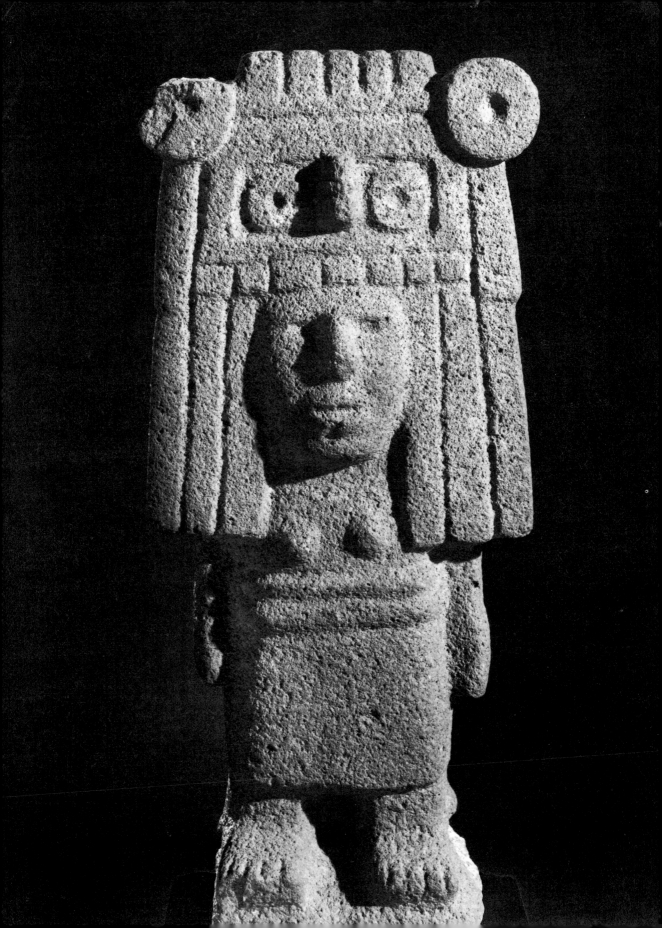

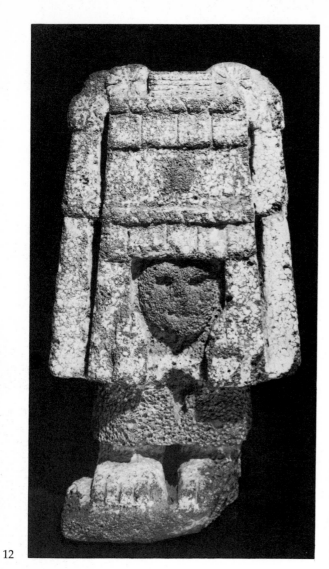

12

11. *Right* Standing figure of Chicomecoatl. Highly stylised sculptures, such as this one and 12 and 13, emphasise the dominant rectangular head-dress which perhaps identifies the goddess Chicomecoatl. This type of head-dress, shown here in considerable detail, is known as the 'temple head-dress', a structure which would have consisted of a flat frame ornamented with paper rosettes, knots and streamers (*amacalli* or 'house of paper') and which was worn by the impersonators of the goddess at festivals. The face emerges from the head-dress as if it were peering out from the doorway of a temple. Similar head-dresses can also be seen in 9-10, and 14-17.

The tasselled *quechquemitl* often worn by the goddess is clearly indicated on this piece.
H 45 cm; granite

12. Standing figure of Chicomecoatl. Traces of red and white paint remain.
H 38 cm; vesicular basalt

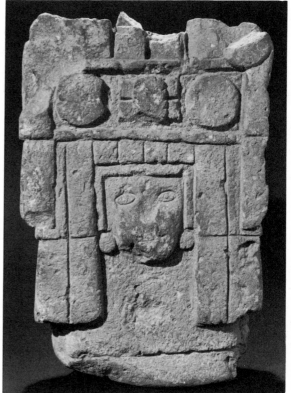

13. Bust of Chicomecoatl.
H 34 cm; basalt

13

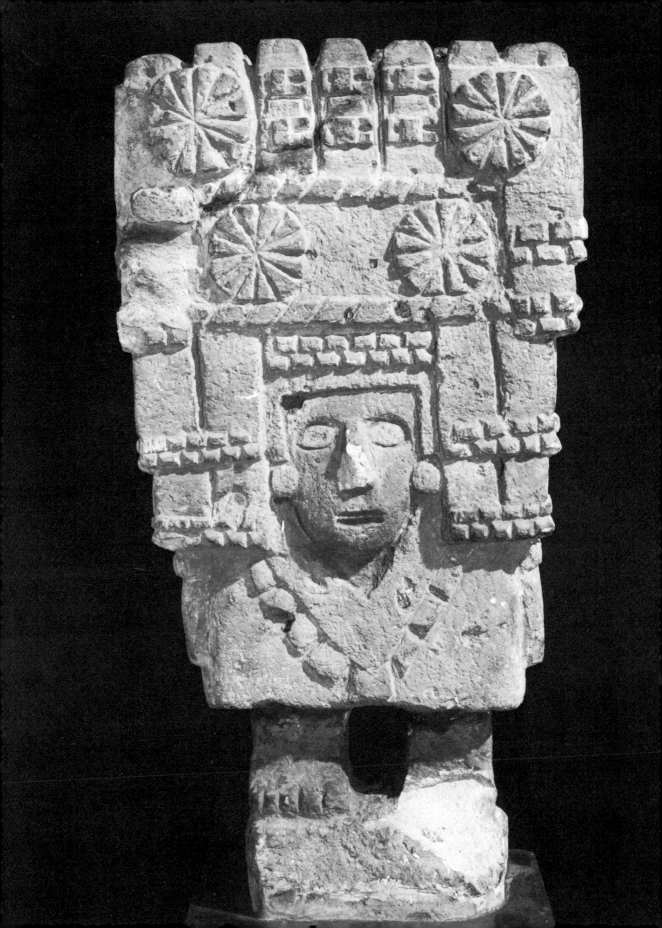

14. Fragment of a figure of Chicomecoatl. The *quechquemitl* is just visible.
H 52 cm; basalt

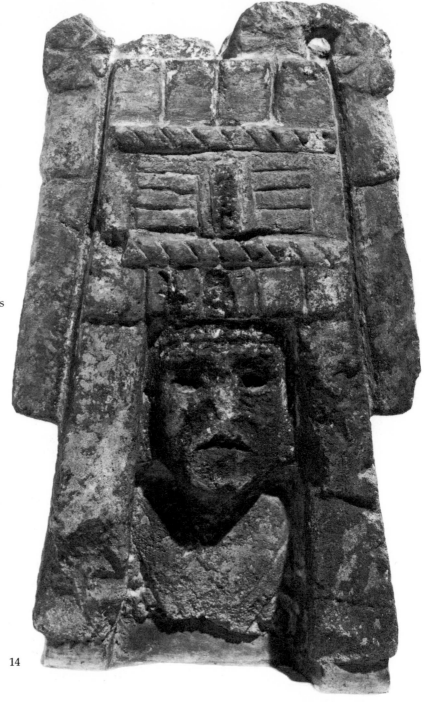

14

15. Female head, possibly of the maize-goddess Chicomecoatl. There are still traces of red paint. H 24 cm; basalt

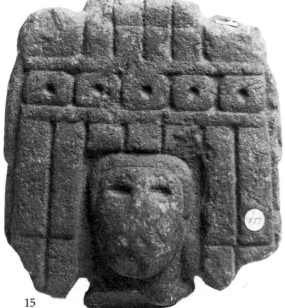

15

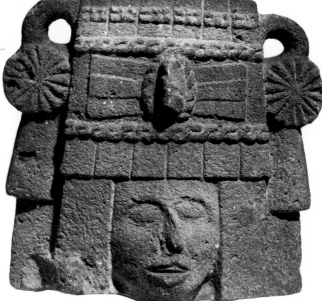

16

16. Fragment of a female figure, possibly of Chicomecoatl. H 21 cm; trachyte

17. Female head, possibly of Chicomecoatl. H 28 cm; basalt

17

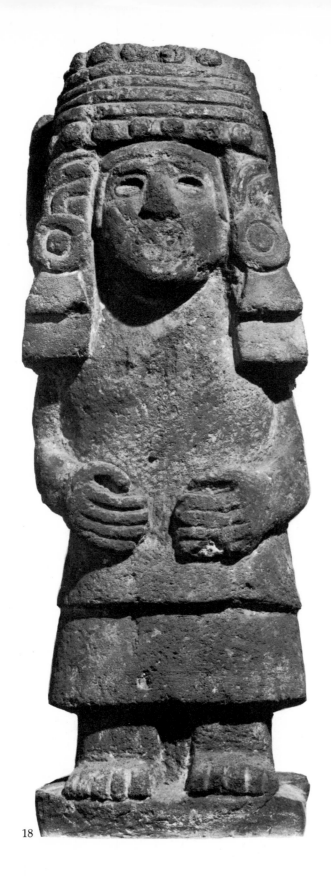

18

18. This female figure has been identified as the Goddess of Sustenance, although some of the attributes shown also belong to the water-goddess Chalchuihtlicue (see pp. 32-4). In this and the following pieces (19-21) the symbolism of the two deities is combined. The fringed and tasselled head-dress with its paper fan at the rear is reminiscent of Chalchiuhtlicue's attire (see 9-11). This figure is identified as Chicomecoatl rather than Chalchiuhtlicue because it seems originally to have held cobs of maize in each hand, though these have vanished.

The goddess wears a skirt and a *huipil*, a loose, blouse-like upper garment worn by Aztec women. H 76 cm; basalt

19. Although this kneeling figure has been identified as Chicomecoatl, she does show attributes of the water-goddess and could well have been intended to represent Chalchuihtlicue. Her *quechquemitl*, fringed with tassels, is shown very clearly. H 36 cm; basalt

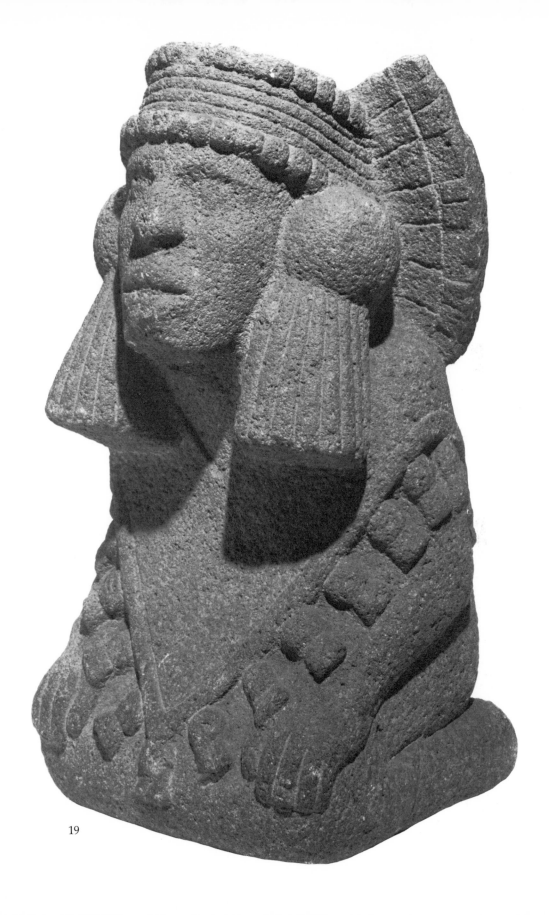

19

21. Fragment from a female figure, possibly Chichomecoatl. Again, this sculpture shows attributes shared by the water-goddess and maize-goddess, particularly in the form of the head-dress. The double maize cobs which she carries, however, point to an identification as Chicomecoatl.
H 39 cm; basalt

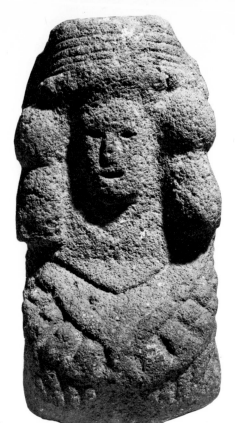

20

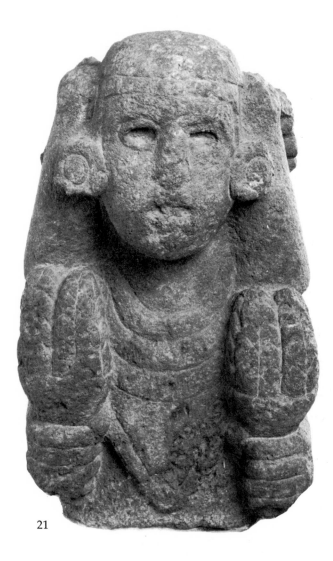

21

20. Kneeling figure, possibly Chicomecoatl. Like 18 and 19, this sculpture also combines characteristics of the water and maize deities. The goddess wears a tasselled *quechquemitl*. The rear view (*below*) shows that the goddess carries a bag containing cobs of maize, which support the identification of this figure as Chicomecoatl.
H 33 cm; basalt

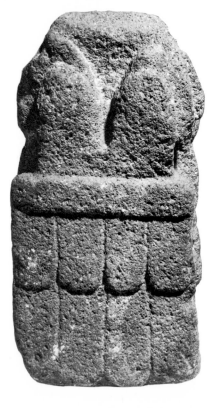

20

Xiuhtecuhtli

The god of fire was a highly venerated deity of great antiquity in Mesoamerica. Fire, as in many other cultures, was a potent symbol for the Aztecs. The hearth at the centre of every household was, like the temple brazier, his sacred place. He was associated with the primordial gods Ometecuhtli and Omecihuatl and was known by many names: Huehueteotl ('the old god'; *huehue* = 'old', *teotl* = 'god') testifies to his antiquitity. He was also called Xiuhtecuhtli (*xiuh* = 'fire', *tecuhtli* = 'lord'). He played an important role in the Aztec calendar as Lord of the Year; the fire-cult associated with him and his festivals was an essential part of the cult of the sun.

The *xiuhcoatl*, or fire-serpent (see 39), was this god's guise.

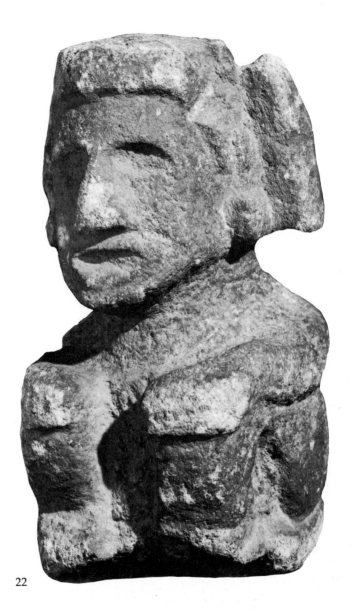

22

22. Seated figure of Huehueteotl, generally portrayed as an aged, wrinkled and toothless old man, as here. His head-dress is decorated with circles, symbols of fire. As Huehueteotl was the patron of hearth and home, figures like this have been found in great number. H 23 cm; basalt

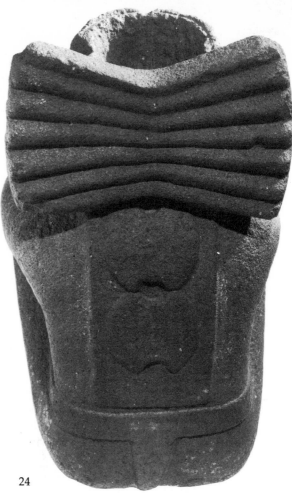

24

23. Seated figure of Huehueteotl.
H 18 cm; basalt

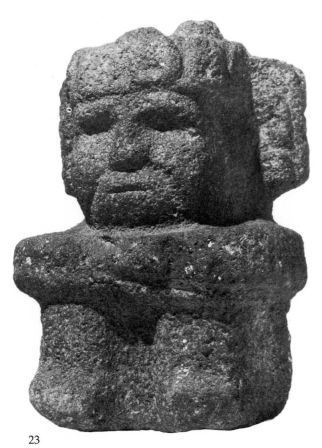

23

24. Seated figure of Xiuhtecuhtli. Several features identify this figure as the fire-god: his head-dress (a band round his forehead decorated with circles sybolising fire, and a pleated pape fan), his ellipsoidal ear-plugs, the fine black line around his eyes, and traces of yellow pigment. He wears a simple loin-cloth.

In the view from the rear (*above*) can be seen a hollow carved out of the top of the fire-god's head. Some sources relate how depressions such as these would contain small fires, lit in honour of the god. Figures like this might have been used as temple braziers.
H 32 cm; basalt

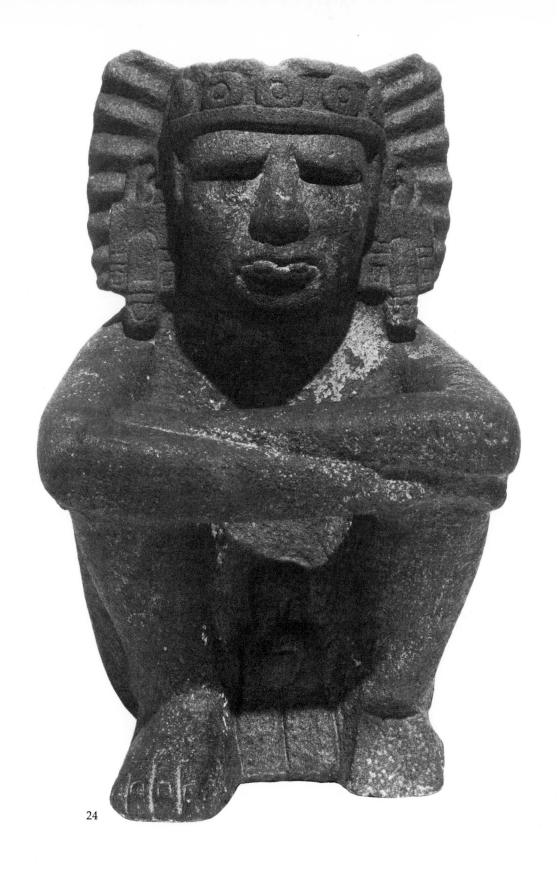

24

Xochipilli

The 'Prince of Flowers', Xochipilli, was, among his other aspects, the god of the dawn and the rising sun, and of love and dance. It was he who decided the outcome of the ritual ball-game. He was also associated with Centeotl as the symbol of the flowering of the maize plant. Blessed with eternal youth and the patron of pleasure in all its forms, he is often portrayed adorned with flowers and red feathers. He was also known as Macuilxochitl.

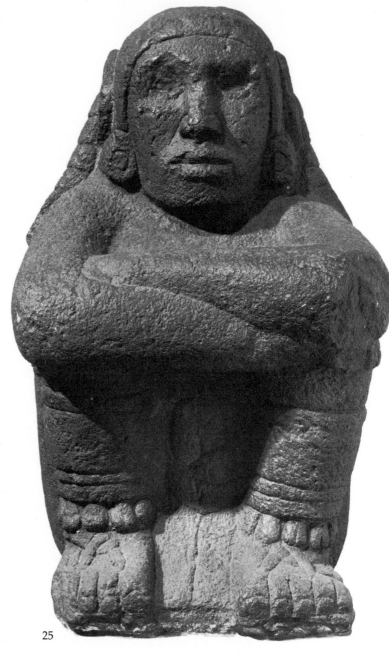

25. Seated figure of Xochipilli. 'The Prince of Flowers' was often shown sitting in this cross-legged position. He wears a loin-cloth and sandals decorated with flowers. There are some traces of red paint. His distinctive helmet-like head-dress is ornamented with stylised feathers.
H 54 cm; basalt

25

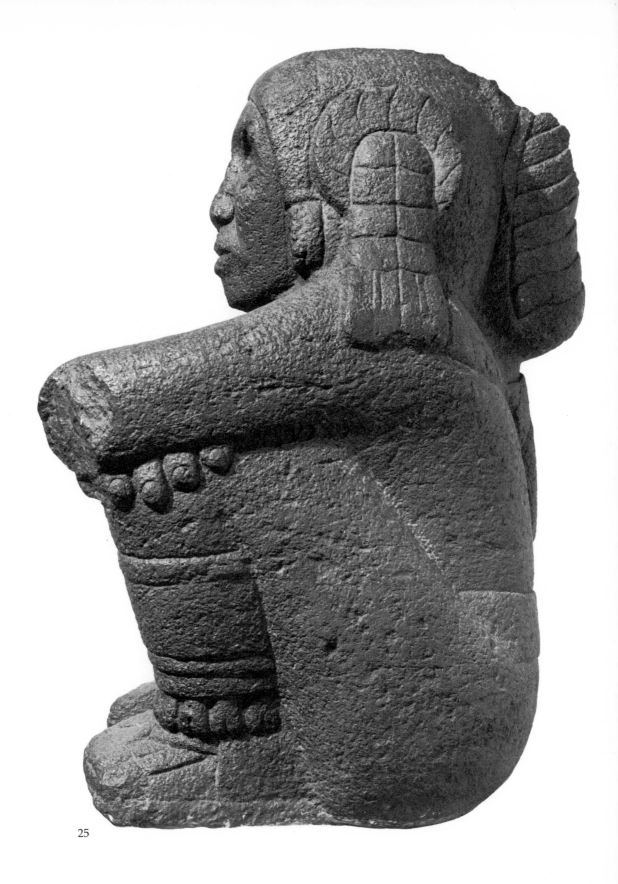

25

25. From the rear, Xochipilli's distinctive headgear is clearly visible. His hair is indicated by vertical lines, falling over his shoulders. A comb-like ornament, tied with a bow and marked with stylised feathers, protrudes from the back of his head and hangs down his back.

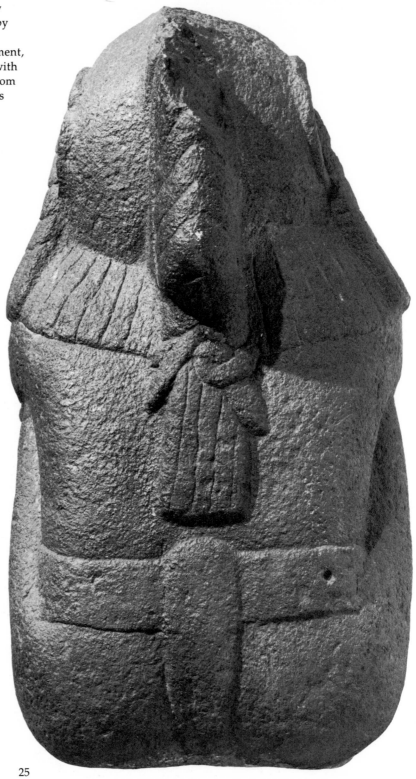

25

Miclantecuhtli

Mictlantecuhtli was the god of death. He ruled over Mictlan, one of the Aztec underworlds. The souls of the dead might go to one of several paradises: in the south was Tlalocan, where the rain-god presided; warriors who fell in battle went to Tonatiuhican in the east, and in the west was the paradise for women who died in childbirth. Those souls who were not eligible for any of these places had to undertake an arduous four-year journey, passing through nine hells and suffering many trials before they might find rest in Mictlan at the centre of the earth.

26. Seated figure of Mictlantecuhtli, wearing a loin-cloth. The skull mask and elongated conical head-dress identify the Lord of the Dead. H 59 cm; basalt

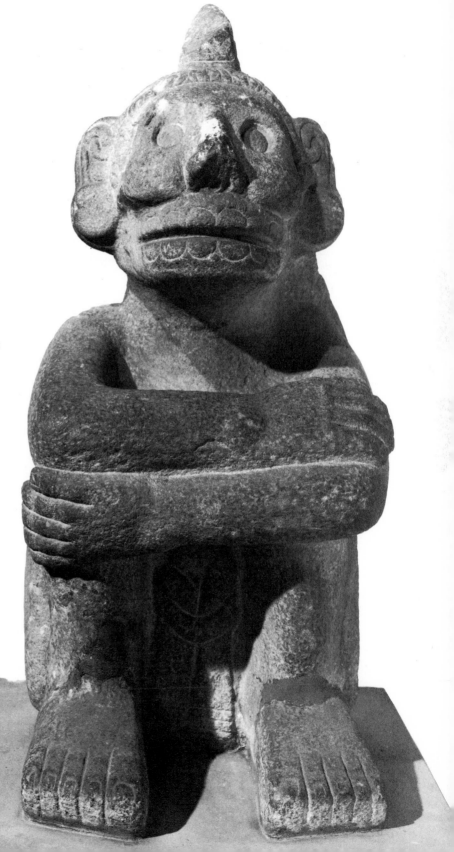

26

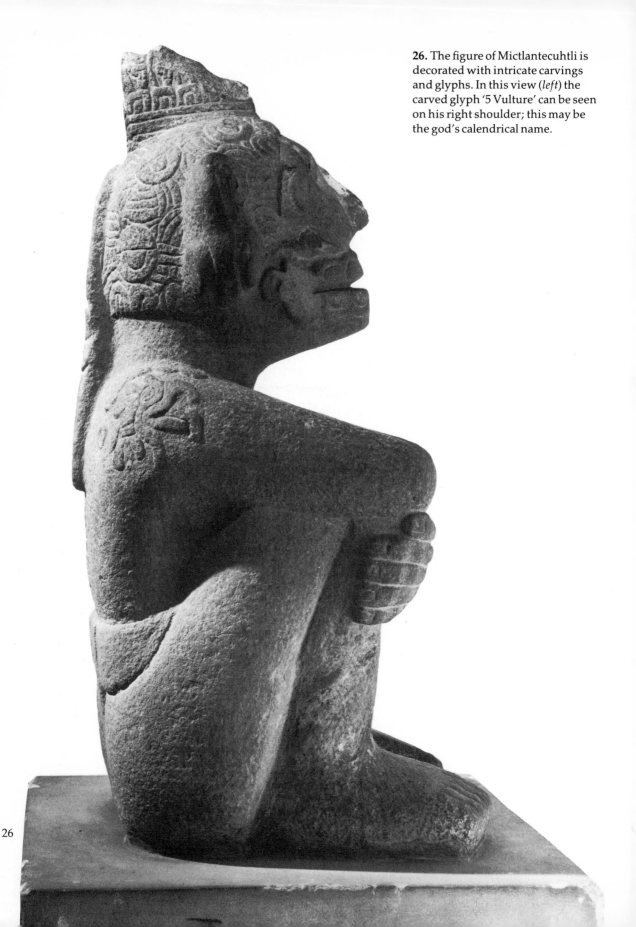

26. The figure of Mictlantecuhtli is decorated with intricate carvings and glyphs. In this view (*left*) the carved glyph '5 Vulture' can be seen on his right shoulder; this may be the god's calendrical name.

26

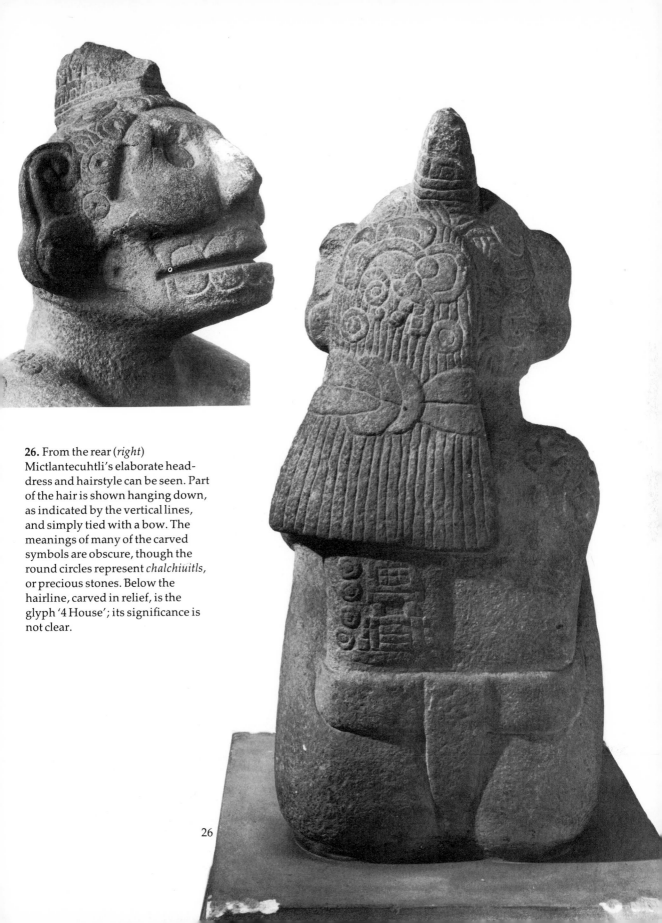

26. From the rear (*right*) Mictlantecuhtli's elaborate head-dress and hairstyle can be seen. Part of the hair is shown hanging down, as indicated by the vertical lines, and simply tied with a bow. The meanings of many of the carved symbols are obscure, though the round circles represent *chalchiuitls*, or precious stones. Below the hairline, carved in relief, is the glyph '4 House'; its significance is not clear.

26

Jaguar Knight

Aztec culture was militaristic in outlook, and war provided for economic as well as religious needs. On the one hand, it enabled tribute to be exacted from subject provinces and, on the other, it provided an opportunity to take prisoners as victims for the sacrificial rites which were thought to be necessary to maintain the sun in its daily course. Thus war became a sacred duty and, ultimately, itself an act of worship. There were three knightly orders: those of the Arrow, Eagle and Jaguar. The order of the Arrow was of less importance, but the Eagle and Jaguar Knights were particularly honoured for their courage and piety, for these orders were dedicated to the service of the sun. The Eagle Knights belonged to Huitzilopochtli's order, and the Jaguar Knights to Tezcatlipoca's. Those who fell on the battlefield, including even the enemies of the Aztecs, and those who died on the sacrificial stone were ensured of a place in the 'Paradise of the East', Tonatiuhican, the house of the sun, where the chosen companions of the sun pursued lives of pleasure and joy.

There are many representations of Eagle and Jaguar Knights in Aztec art. The warriors dressed according to their order and were easily recognised by their costumes, insignia and even their hairstyles.

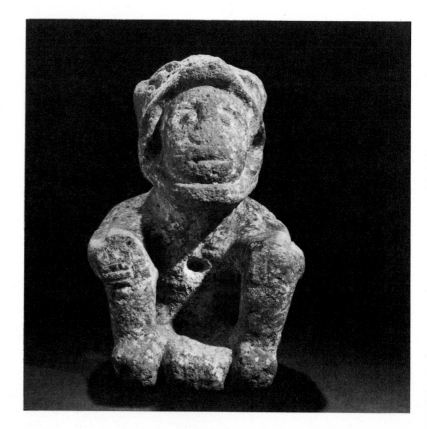

27. Jaguar Knight in battle dress. The uniform worn by the Jaguar Knight consisted of an ocelot skin which fitted tightly over his body and limbs and was pulled up over his head. The head of the animal formed the warrior's helmet; in the side view (*right*) the Jaguar Knight face is clearly visible, peering through the animal's gaping jaws. This sculpture was originally painted white, as traces of paint show.

The jaguar was the guise of the evil warrior-god Tezcatlipoca. H 22 cm; trachyte

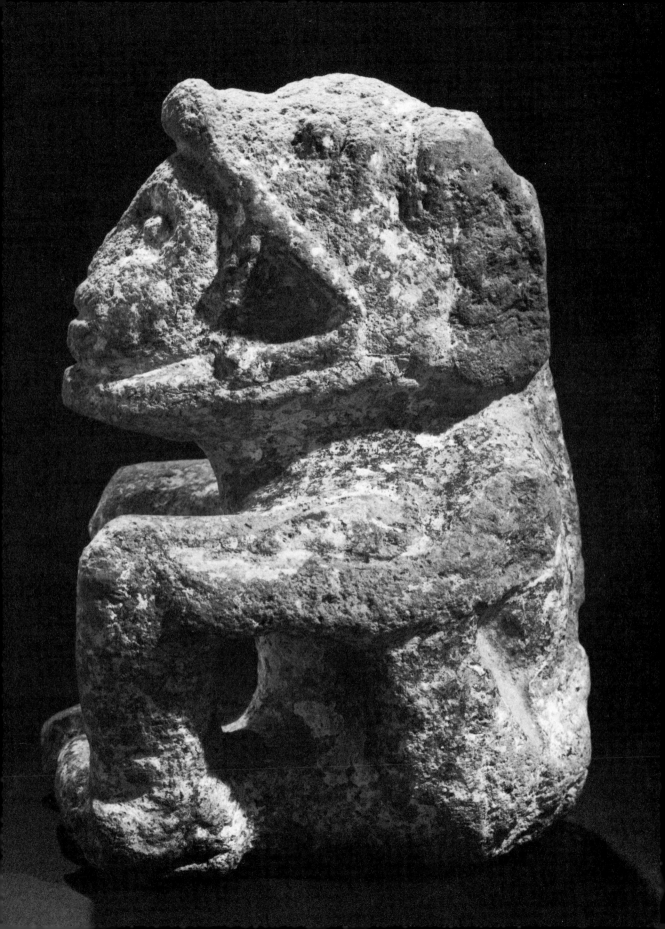

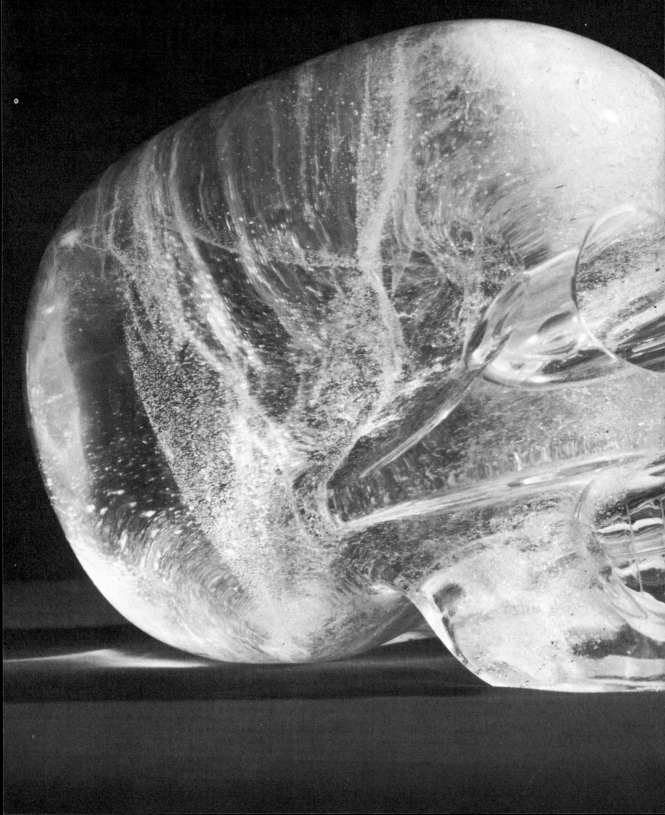

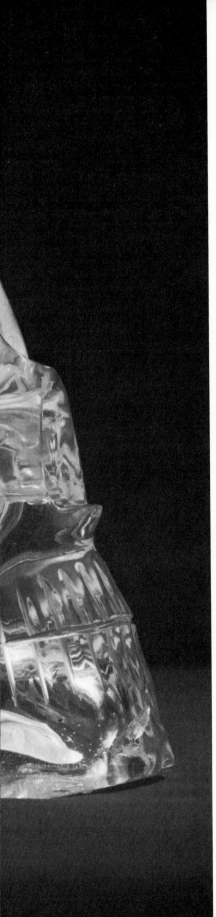

HUMAN FIGURES

The Aztec craftsmen were highly skilled at representing the human form. Portraits executed by Aztec craftsmen do exist – a carving in a cliff at Chapultepec represents Moctezuma the Elder (c. AD 1441-68) – though none of the sculptures illustrated here are portraits of individuals. Nevertheless, they are often very realistic, showing certain features in considerable detail, such as facial wrinkles and pierced ears. Other features might be given in a more schematic way (for example, the hair), but a remarkably life-like impression might still be achieved.

It is not always clear whether a particular sculpture depicts a god or a human being. At festivals and in ceremonies people might array themselves in the insignia of the gods, and figures of the deities showing them with their characteristic headgear and attributes reflected the costumes that their human impersonators would have worn. In other cases, a sculpture might represent a god wearing the clothing of an ordinary man or woman: the loin-cloth (see 24, 25, 26), or the skirt and *quechquemitl* or *huipil* (see 5, 18, 19).

Many sculptures of human figures survive, but as there was little truly secular art even sculptures of men and women – and animals – tend to have religious or symbolic connotations. The sculptures may have been related to particular gods, and were therefore painted in the colours associated with the deities.

Macehualtin

Macehualli (pl. *macehualtin*, 'the chosen or deserved ones') was the name given to the men created by Quetzalcoatl's act of self-sacrifice, but it came to mean the common man, the peasant. Sculptures of *macehualtin* had considerable symbolic content, representing the people and the virtues which they enshrined. For men these virtues included love of work, respect for the elders, loyalty, devotion to duty and to the gods, and obedience.

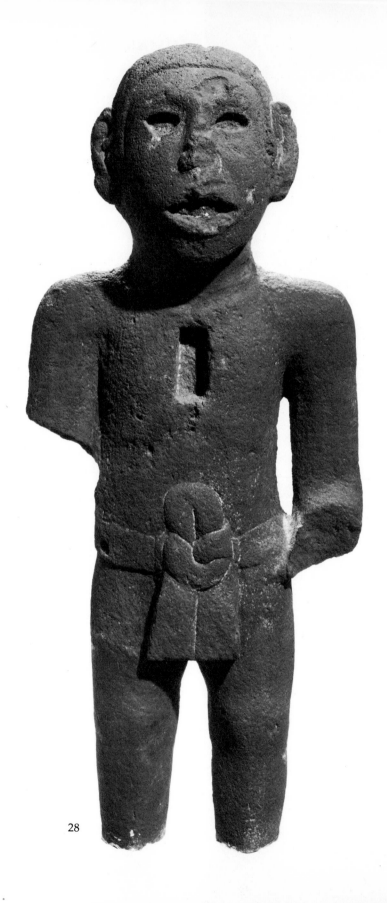

28

28. Standing figure of a *macehualli*. A rectangular slit in the chest indicates where a jade stone, symbolising the heart, would have been set. Jade was felt to be an appropriate symbol for the heart, because it was so highly prized by the Aztecs. Peasants, and others too poor to afford jade, could substitute obsidian, also a symbol of wealth.

This figure wears a simple loin-cloth. Clothing was a great indicator of status among the Aztecs. The nobles wore richly decorated mantles and elaborate head-dresses, and special emblems and insignia set the warriors and priests apart. The ordinary man wore just a loin-cloth (*maxtlatl*), consisting of a length of plain cloth which passed round the thighs and tied in a knot at the front, as here. A more elaborate garment worn by wealthier men, and on special occasions, might have embroidered flaps and be decorated with feathers and stones.

This figure may have been intended to represent the ideal of beauty.

H 56.5 cm; pumice

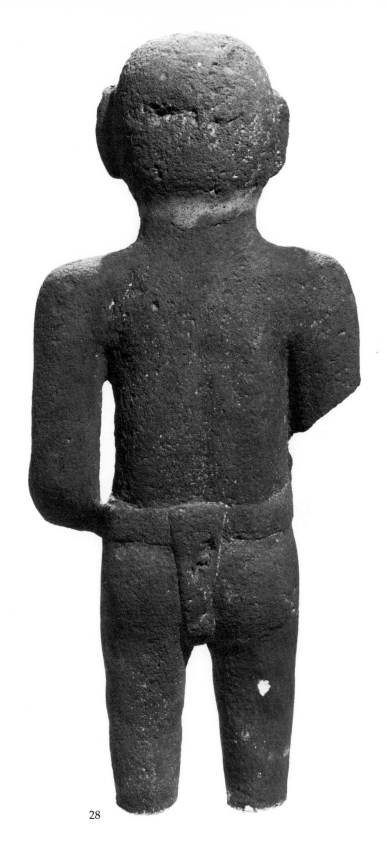

28

29. A squatting, headless *macehualli*, wearing a loin-cloth, viewed from the front (*above*), as well as from the rear (*left*). H 18 cm; basalt

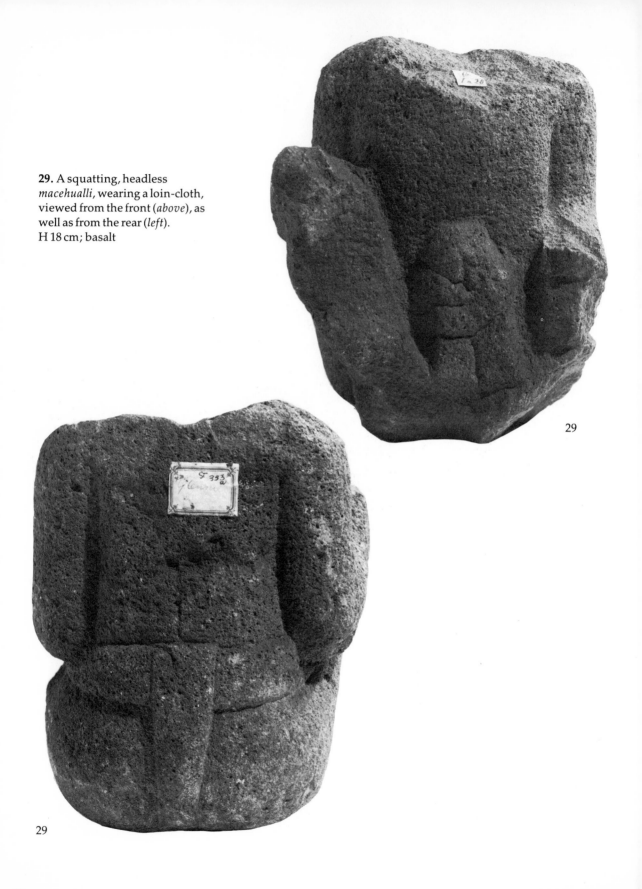

29

29

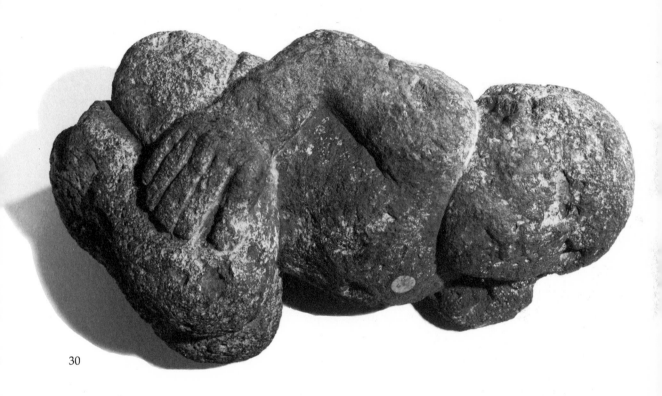

30

30. Male figure reclining on his left side, perhaps wearing a loin-cloth; there are traces of white paint.

This sculpture may portray a deformed child. On its back is a prominence of the kind which can often point to tuberculosis, a disease common among the Aztecs. A number of such sculptures showing deformities are known, and these have been studied by medical researchers for the clues they can give about what sort of ailments the Aztecs suffered from. These representations also point to the Aztecs' own fascination with physical deformity. As in many other societies, people suffering from physical defects were often set apart from the rest of the community: for example, it is known that Moctezuma was entertained by hunchbacks, and that they also appeared in circuses.
H 15 cm, L 35 cm; trachyte

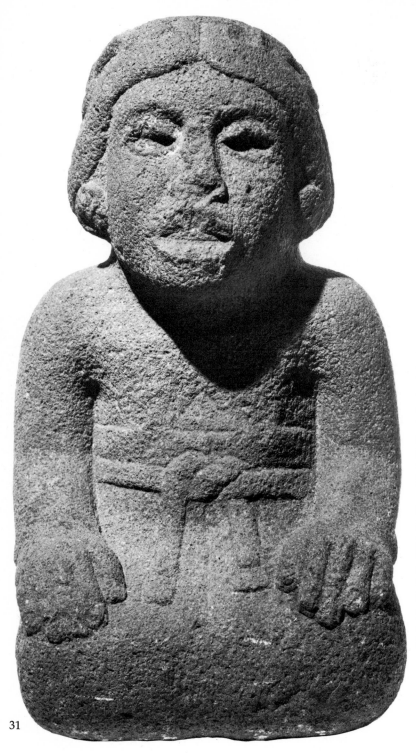

31. This kneeling female figure may represent a goddess, but the simplicity of the clothing and the lack of any recognisable attributes make the identification of any particular deity difficult. The figure is bare-breasted, representing fertility. She kneels, hands resting on her knees, in the common suppliant posture characteristic in statues of women. She wears the principle women's garment, a long sirt reaching almost to the ankles. This consisted of a length of cloth wrapped round the body and held at the waist by an embroidered belt. At festivals and public dances the women wore richer materials with colourful embroidery, but for everyday wear, and for poorer women, the cloth was plain, as shown here. Usually an upper garment, a *quechquemitl* or *huipil*, was worn over the skirt.
H 45 cm; basalt

32. *Right* Head of a man. The facial features of the young man portrayed are rendered realistically, though the hairline is indicated by a simple carved groove. Aztec men wore their hair cut plainly with a fringe over the forehead, although priests and warriors had more elaborate hairstyles.
H 17 cm; trachyte

31

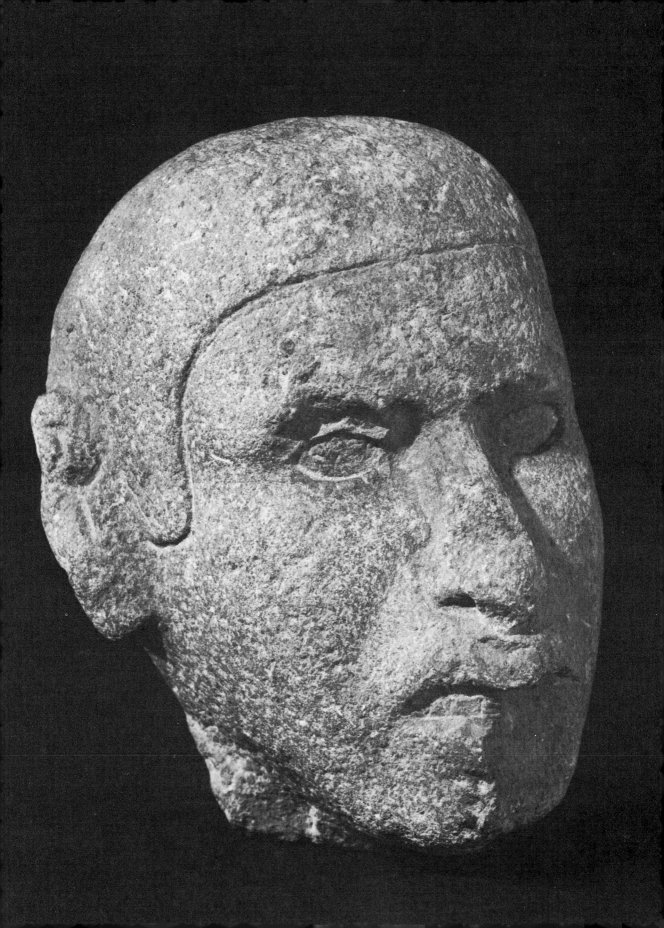

33. Carved head of a man, inlaid with mother-of-pearl for the eyes. Inlays of shell and obsidian were frequently used for the eyes in representations of the human head: the shell for the whites of the eyes and obsidian for the pupils. In this case the use of mother-of-pearl alone gives a startling impression which, together with the open sagging mouth, suggests that this carving may have been intended to represent the head of a dead man.
H 17 cm; basalt

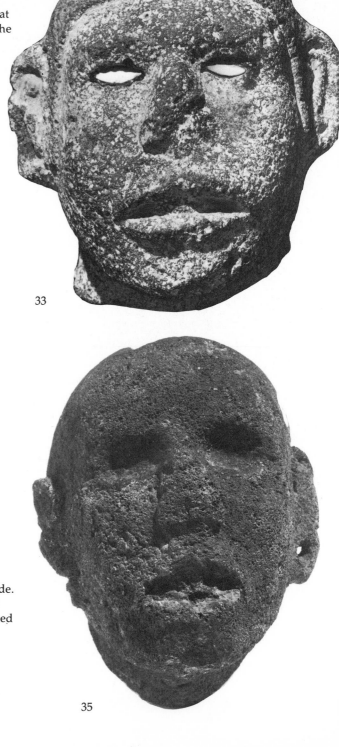

33

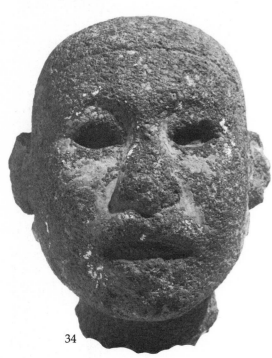

34

34. Head of a young man.
H 15 cm; basalt

35. Head of a young man, the ear-lobes pierced to receive ear-spools. These were cylindrical plugs, usually made of polished stone, which passed through the ear, with ornamental discs on the outside. Boy's ear-lobes were pierced during childhood and fitted with small plugs. These were gradually replaced with larger plugs until the holes had stretched sufficiently to accommodate full-sized ear-spools. Plugs were commonly worn in the nose and lips, as well as in the ear-lobes.

This head still bears traces of black and red paint.
H 15 cm; basalt

35

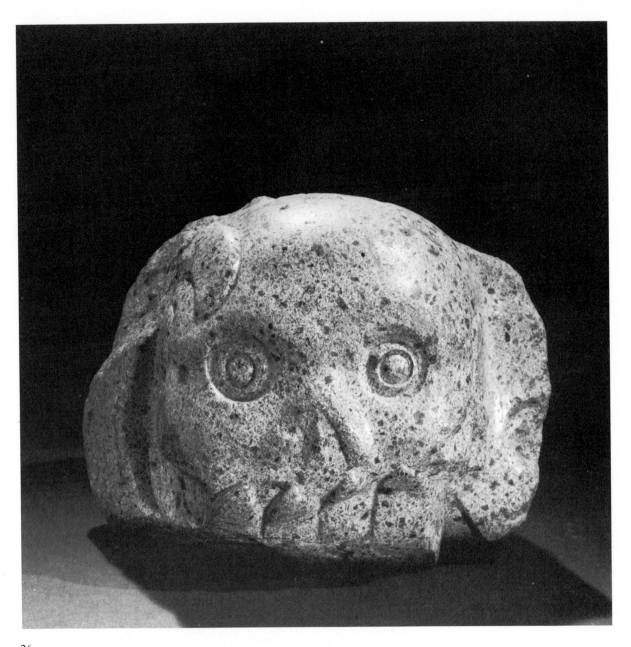

36

36. Carving of a human skull.
Carvings of this type were tenoned
into pyramidal substructures or
used to decoarate shrines. Real
human skulls of sacrificial victims
were also kept in shrines, stored on
racks called *tzompantli*.
H 16 cm; dolerite

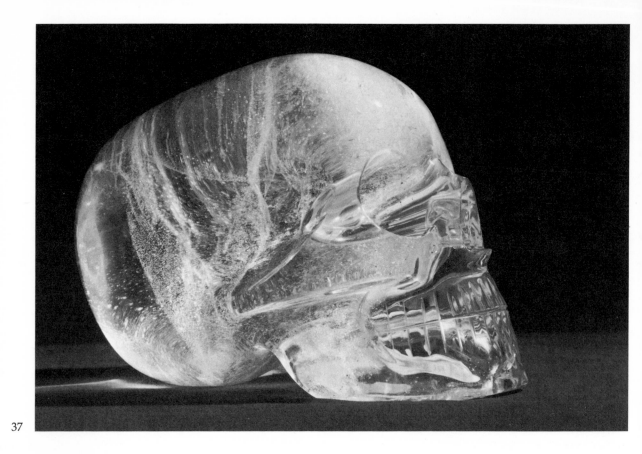

37

37. This magnificent carving of a human skull in rock-crystal presents something of an enigma. The style of the piece alone would date it to the Aztec period, but one line of the surface carving suggests the use of a jeweller's wheel, which was only introduced into Mesoamerica by the Spaniards and would therefore indicate a post-Conquest date.
H 21 cm; rock-crystal

38. Carving, showing a human face apparently emerging from the mouth of a creature. This kind of representation, combining anthropomorphic as well as zoomorphic features, is very common in Mesoamerican art.
L 20 cm

38

THE ANIMAL WORLD

Animals, both real and mythological, were a vital element in Aztec art. In many cases they are portrayed with a painstaking attention to detail which reveals the artist's sympathy with his subject. The early Spanish conquerors of Mexico reported on the menageries and aviaries kept by Moctezuma at Tenochtitlan: 'the king kept . . . all species and varieties of animals, reptiles and snakes which were brought to him from every province . . .'. Gaps in his menageries were filled by images of animals carved from wood and stone and set with precious gems.

The Aztecs' fascination with the natural world had a deep religious and symbolic basis. Animals were thought to be intimately bound up in the affairs of the gods and the ordering of the universe. Many animals had close associations with certain deities, who might appear in the form, or guise, of a particular creature. The jaguar, for example, was the *alter ego* of the warrior-god Tezcatlipoca, and the emblem of the Order of the Jaguar. To the ancient Mexicans the jaguar represented the highest of all virtues – courage. The jaguar was also a symbol of imperial authority. The eagle, companion of the jaguar, was an important symbol of the solar cult; in fact, the Aztecs thought of the sun as an eagle: Quauhtli (= 'eagle') was another name for Tonatiuh, the sun-god. The eagle often appeared in calendrical and mythological texts, and was also the emblem of the knightly Order of the Eagle.

The owl, a bird of ill omen, was associated with Mictlantecuhtli, along with bats, spiders and other nocturnal creatures. A companion of the god of death, the owl was the representative of the night and the powers of darkness.

The names of the gods can often indicate their symbolic associations with particular animals, such as the *-coatl* element in the names of several deities. From the most ancient times the Aztecs revered the snake as a creature of the earth connected with the gods of fertility. Coatlicue, the Earth Mother, was depicted wearing a skirt of intertwined serpents, and the name of the maize-goddess Chicomecoatl means 'Seven Serpent'. It is also seen in the name of Quetzalcoatl, the Feathered Serpent. The snake is the most common of all the animal motifs in Aztec art. It appears in three forms: from the natural world are the realistic representations of the ordinary rattlesnake, and from the supernatural and mythological spheres the Feathered Serpent (symbol of Quetzalcoatl) and fire-serpents (*xiuhcoatl*). Carvings of snakes and serpents flanked the steps of the great Toltec and Aztec temple-pyramids and were used as decorative motifs in architecture. Many examples have survived, varying immensely in size and quality.

Other creatures were also associated with fertility cults. The frog, because of its connection with water, was seen as a symbol of fertility throughout the whole of Mesoamerica. Carvings of aquatic animals might be placed beside the shrines of Tlaloc to propitiate the rain-god. The earth itself was sometimes pictured as a gigantic frog (Tlaltecuhtli). Fish also represented fertility and procreation. According to legend, men were transformed into fish after the fourth era of creation, when the earth was destroyed by floods.

Another creature with symbolic associations was the monkey, who was connected with the pleasures of life: singing and dancing, and music and skill in the arts in general. But he also represented the forbidden sensual pleasures, sin and punishment. It was believed that in the destruction of the earth in the second age of the world by great winds men were changed into monkeys.

Despite their interest in the animal world, the Aztecs had very few domesticated animals, and draught animals were unknown. The dog, one of the few domesticated animals that existed in Mesoamerica, was very important, both in everyday life and in ritual. The dead were thought to require the help of dogs to pass through one of the trials which they had to undergo on their journey to the underworld. Dogs were therefore specially bred to be slain at funerals in order to accompany the dead.

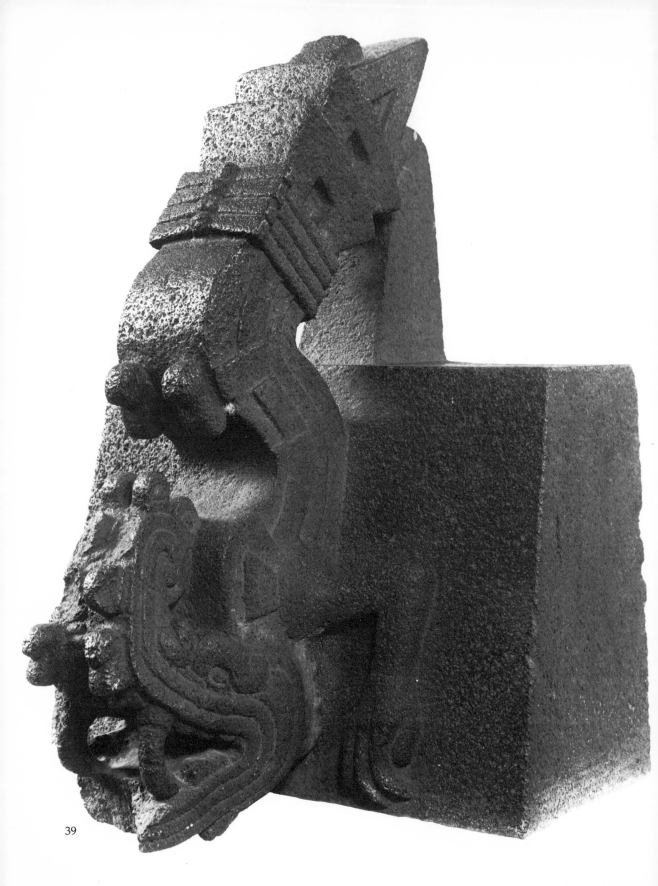

39

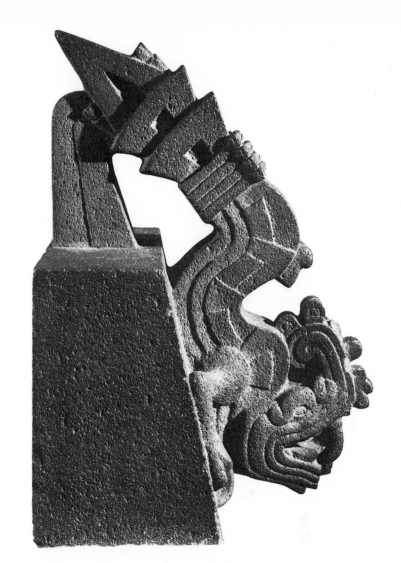

39. Fire-serpent (*xiuhcoatl*). Fire-serpents were important in the cult of the sun. According to myth, fire-serpents assisted Huitzilopochtli to defeat his sister and brothers, the moon and stars, at this birth. The *xiuhcoatl* was also the guise of Xiuhtecuhtli, the fire-god. Carvings of fire-serpents, like this striking example, decorated the walls of temples dedicated to the sun, and the famous 'wall of snakes', which continued the precinct of the Great Temple of Tenochtitlan, was composed of similar carvings. H 76 cm; basalt

39

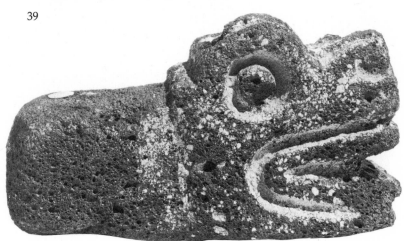

40. Carved serpent's head. Traces of white paint survive. H 12 cm; depth 21 cm; basalt

40

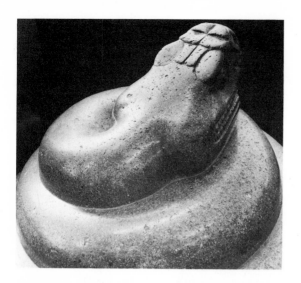

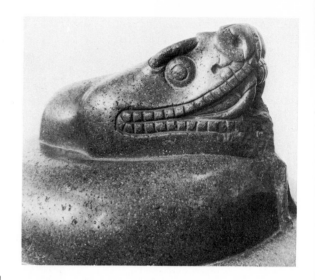

41

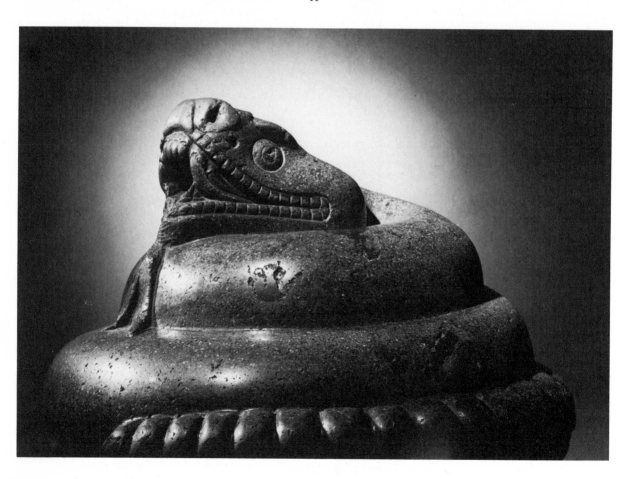

41. Coiled rattlesnake. This superb piece has been carved in minute detail and is remarkably realistic. The snake's rattle is rendered faithfully in the tail and the underside is decorated with red spots.

Rattlesnakes were among the animals kept in Moctezuma's menagerie at Tenochtitlan, as described by Bernál Diaz: 'They had many vipers in this accursed house, and poisonous snakes which have something that sounds like a bell on the end of their tails. These, which are the deadliest serpents of all, they kept in jars and great pottery vessels full of feathers, in which they laid their eggs and reared their young.'
H 35 cm; olivine basalt

42. Coiled snake.
H 22 cm; basalt

43. Coiled rattlesnake.
H 19 cm; trachyte

42

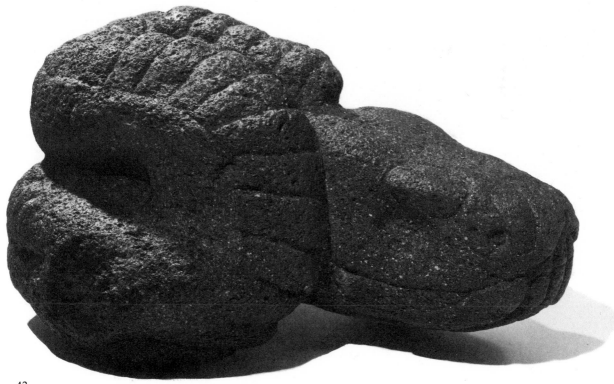

43

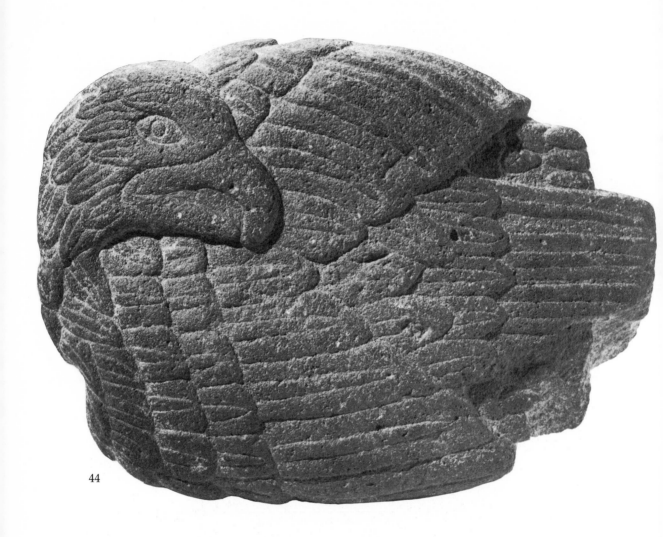

44. Low-relief carving of an eagle.
This is undoubtedly only a
fragment of a larger piece and it is
no longer possible to reconstruct its
original significance, divorced from
its context. This fine carving is
executed realistically and clearly
demonstrates the sensitivity with
which the Aztec artist observed the
natural world.
H 20 cm, L 28 cm; basalt

45. Figure of a headless eagle.
H 50 cm; basalt

45

46. Carving in the form of an owl. A hollow in the owl's back (*below*) forms a recepticle which was probably used to contain the hearts of victims sacrificed to the sun-god. H 25 cm, L 49 cm; basalt

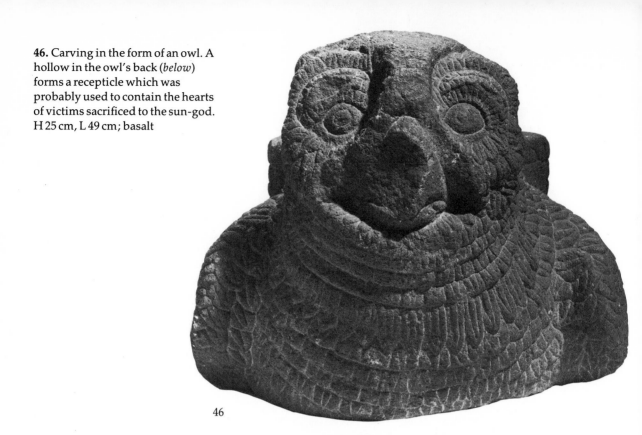

46

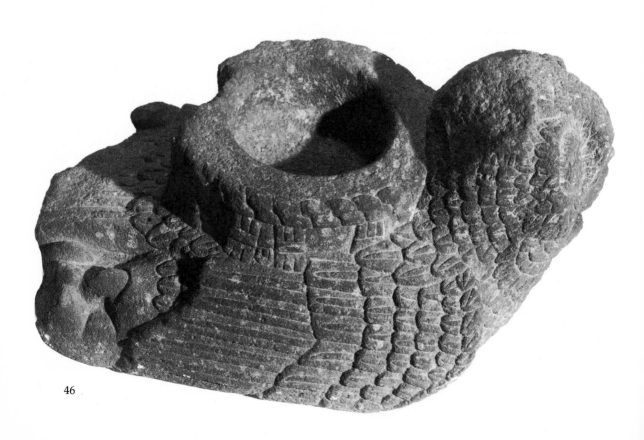

46

47. Carving of a frog.
H 13 cm, L 30 cm, W 27 cm;
sandstone

48. Bas-relief of a fish. A fragment
from a larger carving, with some
traces of white paint.
H 28 cm, L 36 cm; basalt

47

48

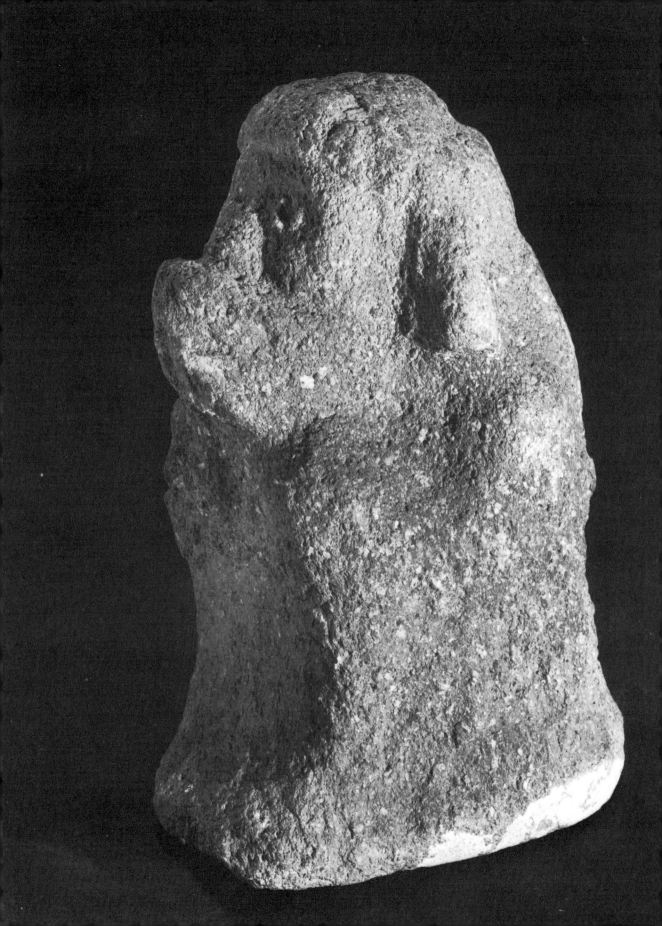

49. *Left* A sitting figure, possibly a monkey.
H 30 cm; trachyte

50. *Below* An animal wearing a twisted collar, possibly a jaguar.
H 29 cm, L 51 cm; basalt

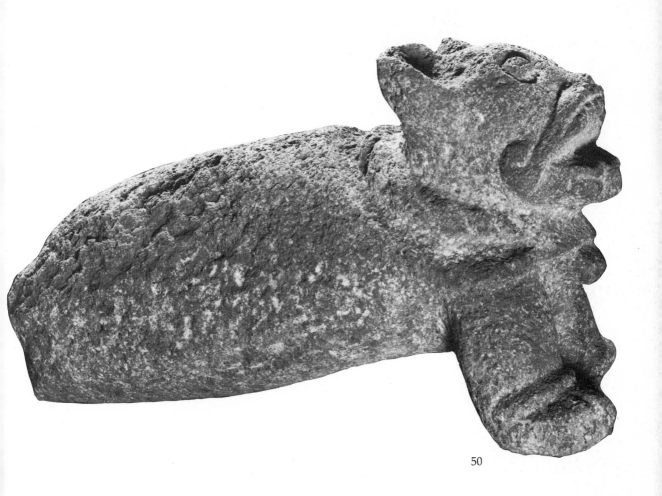

50

49

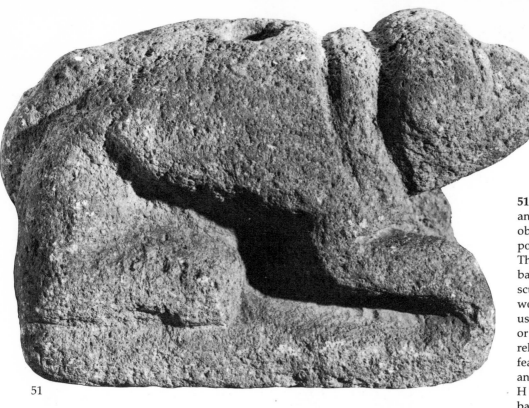

51

51. Crouching animal on a flat oblong base, possibly a dog (?). The hole in the back of the sculpture, which would have been used to hold a flag or a standard, is a relatively common feature in Toltec and Aztec art.
H 16 cm, L 25.5 cm; basalt

52

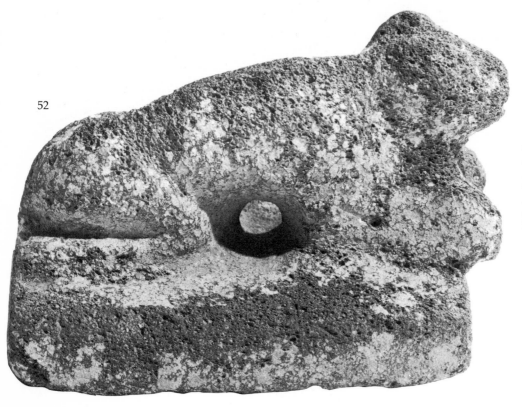

52. Crouching animal, resting on a flat oblong base. There are traces of white paint.
H 12 cm, L 19.5 cm; basalt

RELIEFS, VESSELS
AND BOXES

53. Ovoid stone covered with bas-relief carvings. Many Aztec sculptures have carved symbols of ritual, mythological and cosmological significance, but they are often difficult to interpret and many symbols have yet to be deciphered. In this view the glyph *ollin* can be made out.
H 28 cm, D 47 cm (max.); basalt

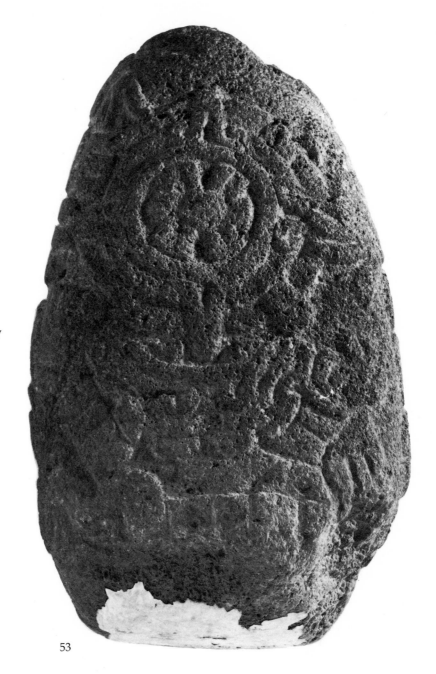

53

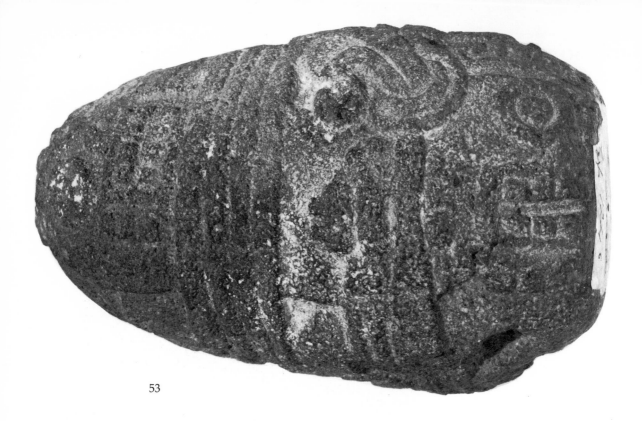

53

54

54. Quatrefoil floral relief, with traces of white paint. Floral motifs were common in relief carvings – the Aztecs were acutely aware of the natural world and took great delight in flowers. Such motifs were carried over by native sculptors into early colonial art, and it is from this period that this example may date. 26 × 23 cm; basalt

53. The problems of interpreting the complex carvings on this piece are compounded by its poor state of preservation. In the views here (*left* and *right*) it is possible to recognise an eye and a mouth.

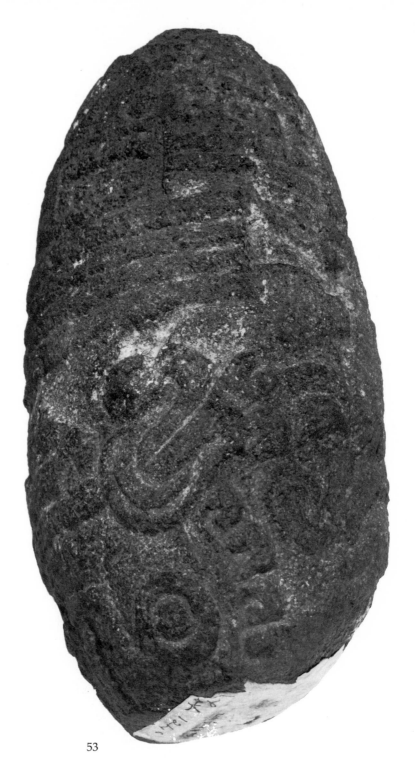

53

Eagle Vessels

Various kinds of vessels and containers survive which would have been used during religious ceremonies. Many sculptures have carved hollows to receive the blood or hearts of sacrificial victims. A type of vessel called *cuauhxicalli* (= 'eagle vessel') is known from many surviving examples, varying in shape and size. They would have been used to hold the hearts of victims sacrificed to the sun-god. Again, the connection between the eagle and the sacrificial sun-cult is demonstrated in the name of this type of vessel.

55. This drum-shaped *cuauhxicalli* is covered with symbolic motifs carved in relief. The top is bordered with stylised hearts, below which are carvings representing droplets of blood and eagle feathers. The main element is the image of the radiant sun-disc in the centre containing the glyph *ollin* (= 'motion' or 'earthquake'). This is a reference to the date on which, according to Aztec belief, the earth would be destroyed by earthquakes. The Aztecs hoped to prevent, or at least postpone, this ·event by means of blood sacrifice. Although these symbols connect the vessel with the sun-cult, on the lower part of the vessel is the date '1 Rain', associated with Tlaloc; the image of the rain-god can also be seen. Thus there may also be, at a secondary level, an association with the cult of Tlaloc.
H 57 cm; basalt

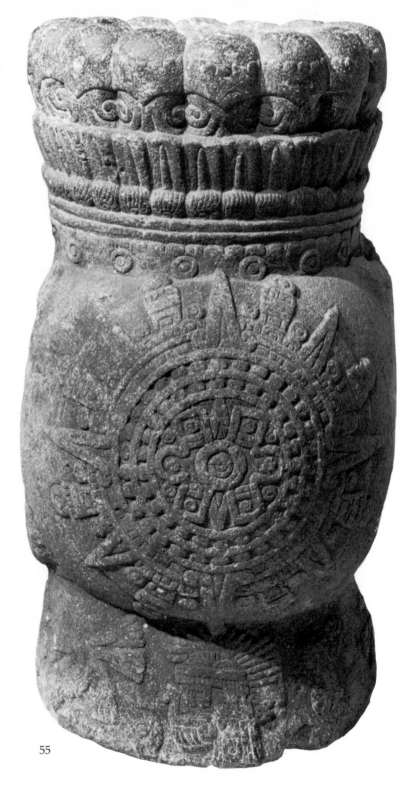

55

56. This fragment is part of the bottom of a large circular stone vessel, probably a *cuauhxicalli*. It is carved in low relief both inside and out. The symbol carved on the inside of the fragment (*right*) includes the glyph *acatl* ('reed' or 'cane'). Although the carving has been damaged, it has been suggested that the symbol should be read as '2 Reed', a date associated with the sanguinary cult of the sun.

The circles and wavy lines carved around the outer bottom rim of the fragmentary vessel (*below*) symbolise the sacrificial victim's precious gift of blood.
H 11.5 cm (max.), D 28.5 cm; basalt

56

56

Chacmools

Another kind of vessel used for holding sacrificial offerings was the *chacmool*. Such figures were executed by the Toltecs. *Chacmools* were intermediaries between the gods and men; a polychrome painted *chacmool* stood near the entrance to the Aztec temple of Tlaloc. Chacmools took the form of reclining figures supporting a bowl, which was a symbol of the life-giving rain and was used to contain blood or other offerings. This type of vessel would have been associated with the cult of the rain-god.

57. *Chacmool*
H 39 cm, L 48 cm; basalt

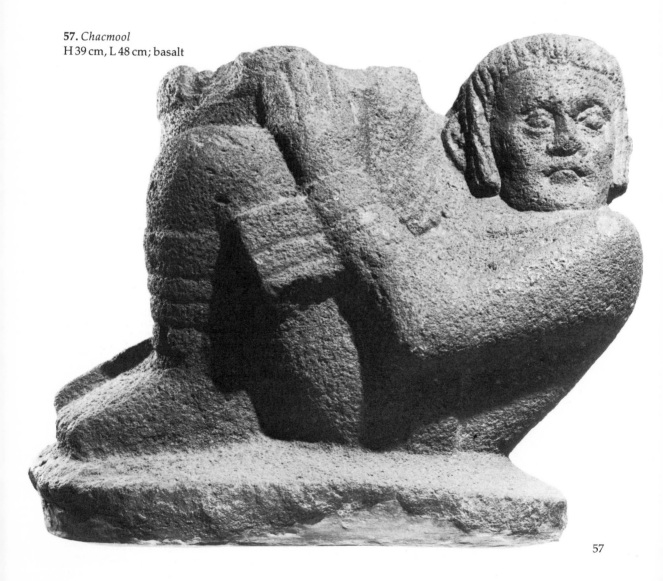

57

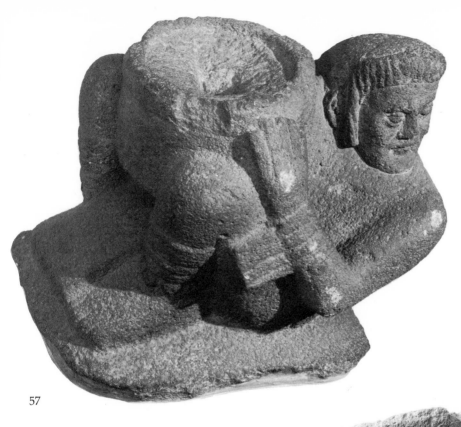

57

57

Boxes

Another category of carvings are presumed to have been sections of boxes. It is not known what the function of these stone boxes might have been, although it has been suggested that some may have been cinerary caskets.

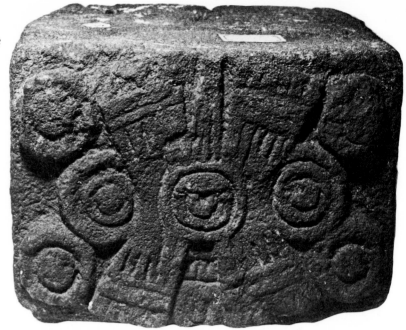

58

58. This stone block was probably the lid of a box. On the top of the block (*top right*) is a relief carving of the glyph *ollin* or 'motion'. The side (*bottom right*) has an eagle facing a seated jaguar, also carved in relief. Both reliefs refer to the cult of the sun. There are also some traces of red paint.
H 19 cm, Th 13 cm; basalt

58

59. Fragment of a stone box (*tepetlacalli* from *tepetl* = 'mountain' or 'country', and *calli* = 'house' or 'temple'; the name indicates the relationship between these stone boxes and funerary rituals). This example is thought possibly to have been part of the cinerary casket of the eighth Mexican ruler, Ahuitzotl. According to some sources Ahuitzotl was drowned in a disastrous flood during the inauguration of an aqueduct known as the Aqueducto de Acuecuexcatl.

The date '7 Reed', which also appears on the box, probably refers to this event. Some of the carvings on the box seem to refer to Ahuitzotl, and there are also ornaments symbolic of water and associated with the rain-god.

The bottom of the vessel (*below*) shows a *tlaloc*, one of the four lesser assistants of Tlaloc, pouring water and ears of maize from a stone vessel. This probably refers to the catastrophic flood.
H 23 cm, W 34.5 cm

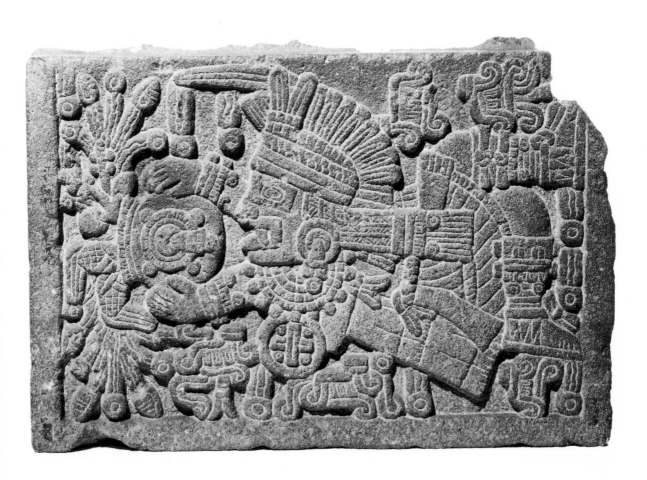

59

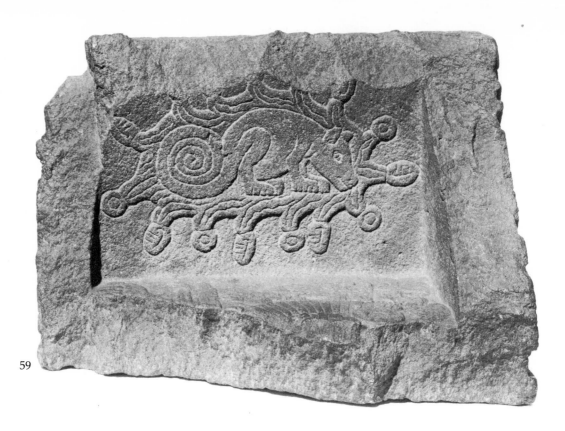

59

59

59

59. Inside of box (*top left*) is a relief of an *ahuitzotl*, a small, mythical, ghost-like water creature that was supposed to live in the lake; it was thought to eat the eyes, nails and teeth of people who had drowned.

Although the association of this box with Ahuitzotl cannot be proved, the symbols seem to refer to his accident and the flood which followed the inauguration of the aqueduct.

Two further fragments (*bottom left*) show parts of similar scenes.

Right This damaged relief from the same box shows part of the earth monster; its arm and leg are decorated with eyes, teeth, bands and feathers. The concentric circles near the top are the ear-ornaments worn by the monster.

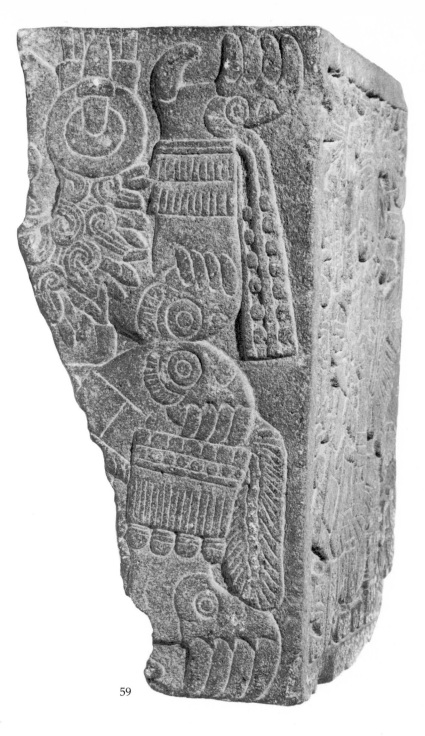

59

The Rulers of
Tenochtitlan

All dates are approximate

ACAMAPICHTLI (1376-91?)

HUITZILIHUITL (1391-c.1416)

CHIMALPOPOCA (1417-27)

ITZCOATL (1428-40)

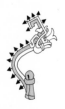

MOCTEZUMA I ILHUICAMINA (1440-68)

AXAYACATL (1468-81)

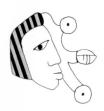

TIZOC (1481-6)

AHUITZOTL (1486-1502)

MOCTEZUMA II XOCOYOTZIN (1502-20)

CUAUHTEMOC (1520-1)

Glossary and Index

CENTEOTL (*centli* = 'maize', *teotl* = 'god'). The god of maize and the personification of the maize plant. See also **Chicomecoatl** and **Xilonen**.

CHACMOOL A reclining figure supporting a dish to receive sacrificial offerings. Aztec *chacmools* were modelled on Toltec prototypes, but constitute a departure from the earlier examples with their greater realism and wealth of symbolic detail.
See pp. 8, 86-7

CHALCHIUITL ('precious stone'). *Chalchiuitl* had a wide range of meanings. Because it signified something that was very precious, such as jade, it came to have the symbolic meaning of blood, 'the precious liquid'. Blood sacrifices to the gods preserved the natural order of the Universe and, thus, all life. Symbols of turquoise and jade frequently represented blood in Aztec art.
See pp. 16, 19, 22, 55

CHALCHIUHTLICUE ('The Lady of the Jade Skirt' or 'Lady Precious Green': *chalchiuitl* = 'jade', *cueitl* = 'skirt'). The companion of **Tlaloc** (*q.v.*) – either his sister or his wife – Chalchiuhtlicue was the goddess of the rivers and lakes, and patroness of fishermen and all who made their living from the water.
See pp. 7, 15, 16, 19, 25, 32-4

CHICOMECOATL ('Seven Serpent'). The 'Goddess of Sustenance', Chicomecoatl represented the ripe maize seed and was one of the most important fertility deities in the Aztec pantheon. See also **Centeotl** and **Xilonen**.
See pp. 9, 25, 38-46, 69

COATLICUE ('Lady of the Skirt of Serpents': *coatl* = 'serpent' *cueitl* = 'skirt'). Represented with symbols of fertility (serpents) and death (a necklace of skulls, hands and hearts), she is the earth-goddess and mother of the warrior-god **Huitzilopochtli** (*q.v.*). She was also known as 'Our Mother' and 'Mother of the gods'.
See pp. 17, 19, 69

COYOLXAUHQUI ('Lady Golden Bells': *coyaulli* = 'rattle', *xauhqui* = 'painted ornament'). The daughter of **Coatlicue** (*q.v.*), Coyolxauhqui was the goddess of the moon and of the night who, together with her brothers the stars (called collectively the Centzonhuitznahu) was defeated by **Huitzilopochtli** (*q.v.*) at his birth.
See p. 17

CUAUHXICALL ('eagle vessels'). Sacrificial containers used in connection with the cult of the sun-god.
See pp. 84-5

EHECATL ('wind' in Nahuatl). The ancient god of the wind and sometimes associated with one of the aspects of **Quetzalcoatl** (*q.v.*).
See pp. 18, 29-30

HUEHUETEOTL ('The Old God': *huehue* = 'old', *teotl* = 'god'). The ancient Mesoamerican god of fire, conceived as the oldest of the gods. Also known as **Xiuhtecuhtli** (*q.v.*).
See pp. 47-8

HUITZILOPOCHTLI ('Hummingbird of the South'). The tribal god of the Aztecs who, according to legend, led his people from their homeland until they settled at Tenochtitlan. He came to be particularly associated with war and sacrifice, both activities which were necessary to nourish the sun. The son of **Coatlicue** (*q.v.*), Huitzilopochtli was the warrior-god whose service the Aztecs saw as their special destiny.
See pp. 9, 10, 11, 12, 15, 16-18

MACEHUALLI ('the chosen or deserved one'; pl. *macehualtin*). The name given to the men created by **Quetzalcoatl** (*q.v.*), it came to mean the common man.
See pp. 16, 60-6

MACUILXOCHITL ('Five Flower'). The patron of games, dance and sports, also called **Xochipilli** (*q.v.*).

MICTLAN: the Aztec underworld, thought to be located to the north and ruled over by the god and goddess of death, **Mictlantecuhtli** and **Mictlancihuatl** (*q.v.*). This was the place where souls not eligible for the paradises of the south, the east and the west, were destined to enter, after completing many arduous trials. See also **Tlalocan** and **Tonatiuhican**.
See p. 53

MICTLANTECUHTLI ('The Lord of the Dead': *Mictlan* = 'the underworld', *tecuhtli* = 'lord'). The god of death who, together with Mictlancihuatl, ruled over Mictlan.
See pp. 16, 53-5, 69

MICTLANCIHUATL: the consort of **Mictlantecuhtli** (*q.v.*)

OLLIN ('earthquake' or 'motion'). 'Four earthquake' or '4 Motion' (*nahui ollin*) was an important date in the Aztec calendar and was also the name given to the fifth age of the world. The end of this age was expected to take place in a year which ended with the date '4 Motion'. This fifth era of the world was thought to be presided over by **Tonatiuh** (*q.v.*), the sun-god, and therefore the glyph *ollin* is found as a symbol on many objects, but especially on those associated with the cult of the sun.
See pp. 16, 81, 84, 88

OMETECUHTLI ('Two Lord' or 'Our Lord of Duality': *ome* = 'two', *tecuhtli* = 'lord'). According to legend, the sons of Ometecuhtli were the four gods who created the world and man. Ometecuhtli was also known as 'Lord of Sustenance' (Tonacatecuhtli: *tonacatotl* = 'nourishment'.)
See pp. 15, 47

OMECIHUATL (also Tonacacihuatl): the consort of **Ometecuhtli** (*q.v.*).

QUETZALCOATL ('Feathered Serpent', also 'Precious Twin': *quetzal* = 'feather' or 'twin', *coatl* = 'serpent' or 'precious'). An important god in the Aztec pantheon, Quetzalcoatl shows a number of varied attributes and aspects. One of the four creator gods, Quetzalcoatl was seen as the god of life, of the arts and of the wind, and appeared as the morning star. He was also bound up in Aztec mythology as a semi-legendary figure whose return would herald the end of the world.
See pp. 7, 8, 15-16, 18, 21, 22, 26-8

TEOTIHUACAN: the principal centre of an important Mexican civilisation of the so-called Classic period of Mesoamerican prehistory and situated 20km to the north-east of modern Mexico City. It was destroyed in AD 650, but remained a centre of religious pilgrimage into Aztec times.
See pp. 7, 16

TENOCHTITLAN ('The Place of the Fruit of the Cactus'). The capital of the Aztec Empire, built on an island in the middle of Lake Texcoco on the site of the modern Mexico City.
See pp. 7, 11, 12, 69

TEZCATLIPOCA ('Smoking Mirror': *tezcatl* = 'mirror', *popoca* = 'to smoke'). The ancient rival of **Quetzalcoatl** (*q.v.*) and one of the four creator gods, Tezcatlipoca's symbol was a mirror of polished obsidian; he is often portrayed with one foot replaced by an obsidian mirror. The eternally young and all-powerful god of the night-sky and patron of sorcerers and magicians, Tezcatlipoca was often portrayed as a jaguar, and was identified with the constellation of the Great Bear, in which the Aztecs saw the form of the jaguar.
See pp. 8, 15-16, 22, 56, 69

TLALOC ('He who makes thing grow'). One of the most ancient of

Mesoamerican fertility deities, Tlaloc was the god of all water, and the lord of **Tlalocan** (*q.v.*), the watery paradise of the south.
See pp. 15, 16, 18-19, 30-1, 69

TLALOCAN: one of the Aztec paradises, thought to be located in the south. Tlalocan was the destination of the souls of those who had died by drowning or from diseases associated with **Tlaloc** (*q.v.*), and was a place of lush vegetation and abundance.
See pp. 19, 30

TLALOCS: the four *tlalocs* were thought of as the dwarfish assistants of **Tlaloc** (*q.v.*). They each had their own proper name and characteristics, and symbolised the mountains surrounding the Valley of Mexico, as well as the departed ancestors.
See pp. 7, 89, 90

TLOQUE NAHUAQUE ('Lord of Everywhere'). Thought by some to be the origin of all things, preceding even **Ometecuhtli** and **Omecihuatl** (*q.v.*) as the primary creative force, incorporating both the female and male principals, and from which all else descended.
See p. 18

TONATIUH: the sun-god, also called the 'Shining One', the 'Beautiful Child' and the 'Eagle that soars'. He was closely associated with **Huitzilopochtli** (*q.v.*) and the eagle. The central figure of the famous Aztec calendar stone shows Tonatiuh, who clutches in his taloned eagle-claws the hearts of human beings.
See pp. 16, 69

TONATIUHICAN ('The House of the Sun'). The paradise of the west, where the souls of those who had fallen on the field of battle or had died in the sacrificial rites were received; here they pursued an existence of bliss as a reward for the ultimate service they had rendered to the sun-god.

TULA: the ancient capital of the Toltec culture. The Aztecs considered themselves to be the spiritual heirs of the Toltecs.
See pp. 8-9

TZOMPANTLI ('skull-rack'). Altars displaying the skulls of sacrificial victims or sculptures of these altars decorated with carvings of human skulls. See pp. 8, 67

XILONEN (*xilotl* = 'young ear of maize', *nenen* = 'doll'). A youthful fertility goddess, representing the maize seed before it has ripened.
See p. 38; see also **Chicomecoatl**.

XIPE TOTEC ('Our Lord the Flayed One'). Originally a god of vegetation and agriculture, Xipe Totec was also a god of spring and the patron of jewellers. He was one of the four creator gods, known as the Red Tezcatlipoca.
See pp. 15, 19, 35-7

XIUHCOATL (fire-serpent: *xiuh* = 'fire', *coatl* = 'serpent'). Closely associated with the myth of the birth of **Huitzilopochtli** (*q.v.*) who was helped by *xiuhcoatls* in his victory over his brothers and sister. The *xiuhcoatl* was also the guise of the fire-god **Xiuhtechtli** (*q.v.*).
See pp. 17, 47, 69, 70-1

XIUHTECUHTLI (*xiuh* = 'fire', *tecuhtli* = 'Lord'). The cult of **Huitzilopochtli** (*q.v.*). He also played an important role on the Aztec ceremonial calendar, especially in connection with the ceremony of the New Fire which took place every fifty-two years. Also known as **Huehueteotl**.
See pp. 20, 47-9

XOCHIPILLI ('The Prince of Flowers'). The patron of dancing, music, games and sport, he was associated with love and the spring. Also known as Macuilxochitl.
See pp. 20, 50-2

XOCHIQUETZAL ('Precious Flower'). The personification of beauty and love, and the wife of **Xochipilli** (*q.v.*).

List of Sculptures Illustrated

1. Bust of Quetzalcoatl
Height 35 cm; jade
Bullock Collection. 1825. 12-10.11

2. Standing figure of Ehecatl
Height 38 cm; basalt
St. 344

3. Mask of Ehecatl
Height 22 cm; granite
1945. Am. 5.1

4. Head of Tlaloc
Height 22 cm; basalt
Ex. Wellcome Collection.
1954. W.AM.5. 1478

5. Kneeling figure of
Chalchiuhtlicue
Height 28 cm; basalt
Bullock Collection. 1825. 12-10.6

6. Head of Chalchiuhtlicue (?)
Height 23 cm; basalt
St. 375

7. Mask of Xipe Totec
Height 22.8 cm; diorite
Ex Christy Collection. 1956. AmX.6

8. Mask of Xipe Totec
Height 22.8 cm; diorite
1902.11-14.1

9. Standing figure of
Chicomecoatl (?)
Height 53 cm; basalt
Glennie Collection. St. 376

10. Standing figure of
Chicomecoatl (?)
Height 63 cm; basalt
1954. W.AM.5. 1479

11. Standing figure of Chicomecoatl
Height 45 cm; granite
1923.11.5.1

12. Standing figure of Chicomecoatl
Height 38 cm; vesicular basalt
St. 382

13. Bust of Chicomecoatl
Height 34 cm; basalt
Bullock Collection. 1825.12-10.10

14. Fragment of a figure of
Chicomecoatl
Height 52 cm; basalt
Ex. Heaven Collection. Hn 167

15. Head of Chicomecoatl (?)
Height 24 cm; basalt
St. 377

16. Fragment of figure of
Chicomecoatl (?)
Height 21 cm; trachyte
Glennie collection. St. 379

17. Head of Chicomecoatl (?)
Height 28 cm; basalt
Glennie Collection. St. 380

18. Figure of Chicomecoatl
Height 76 cm; basalt
Wetherall Collection. 1849.6-29.4

19. Kneeling figure of Chicomecoatl
Height 36 cm; basalt
Christy Collection. Ex. Glennie
Collection. St. 373

20. Kneeling figure of
Chicomecoatl (?)
Height 33 cm; basalt
Glennie Collection. St. 374

21. Fragment of figure of
Chicomecoatl (?)
Height 39 cm; basalt
Ex. Uhde Collection. 8626

22. Seated figure of Huehueteotl
Height 23 cm; basalt
1909.2-18.2

23. Seated figure of Huehueteotl
Height 18 cm; basalt
5527

24. Seated figure of Xiuhtecuhtli
Height 32 cm; basalt
Wetherall Collection. 1849.6-29.8

25. Seated figure of Xochipilli
Height 54 cm; basalt
Bullock Collection. 1825.12-10.5

26. Seated figure of Mictlantecuhtli
Height 59 cm; basalt
Wetherall Collection. 1849.6-29.2

27. Jaguar Knight
Height 22 cm; trachyte
St. 345

28. Standing figure of a *macehualli*
Height 56.5 cm; pumice
8625

29. Squatting figure of a headless
macehualli
Height 18 cm; basalt
Glennie collection. St. 353a.

30. Reclining figure of a *macehualli*
Height 15 cm; Length 35 cm;
trachyte
St. 489

31. Kneeling figure of a woman
Height 45 cm; basalt
Purchased from C. Young Esq.
1922.12.11.1

32. Head of a man
Height 17 cm; trachyte
St. 490

33. Head of a man
Height 17 cm; basalt
1923. 11-5.2

34. Head of a man
Height 15 cm; basalt
Bullock Collection. 1825.12-10.18

35. Head of a man
Height 15 cm; basalt
St. 492

36. Carving of a skull
Height 16 cm; dolerite
Uhde Collection; 8622

37. Rock-crystal carving of a skull
Length 21 cm; rock-crystal
1898.1

38. Anthropomorphic figure
Length 20 cm
Uhde Collection; 8621

39. Fire-serpent
Height 76 cm; basalt
Bullock Collection. 1825.12-10.1

40. Head of a serpent
Height 12 cm; Depth 21 cm; basalt
St. 359

41. Coiled rattlesnake
Height 35 cm; olivine basalt
1849.6-29.1

42. Coiled snake
Height 22 cm; basalt
St. 356

43. Coiled rattlesnake
Height 22 cm; trachyte
Bullock Collection. 1825.12-10.7

44. Bas-relief of an eagle
Height 20 cm; Length 28 cm; basalt
Ex. Uhde Collection. 8624.

45. Headless eagle
height 50 cm; basalt
Bullock Collection. 1825.12-10.2

46. Vessel in the form of an owl
Height 25 cm; length 49 cm; basalt
Bulock Collection. 1825.12-10.3

47. Frog
Height 13 cm; Length 30 cm; Width 27 cm; sandstone
Q83 Am 467

48. Bas-relief of fish
Height 28 cm; Length 36 cm; basalt
St. 371

49. Sitting figure of a monkey (?)
Height 30 cm; trachyte
Glennie Collection. St. 346

50. Jaguar (?)
Height 29 cm; Length 51 cm; basalt
Wellcome Collection.
1945.W.AM.5.1480

51. Crouching dog (?)
Height 16 cm; Length 25.5 cm;
basalt
Ex. Uhde Collection. 8623

52. Crouching animal
Height 12 cm; Length 19.5 cm;
basalt
St. 631

53. Ovoid stone with reliefs
Height 28 cm; diameter 47 cm (max); basalt
1954.W.AM.5.1477

54. Floral relief
26 × 23 cm; basalt
St. 372a

55. Eagle vessel (*cuauhxicalli*)
Height 57 cm; basalt
Purchased Christy Fund (Consul Doormann). +6185

56. Fragments of an eagle vessel
(*cuauhxicalli*)
Height 11.5 cm; diameter 28.5 cm;
basalt
St. 372b

57. *Chacmool*
Height 39 cm; Length 48 cm; basalt
Bullock Collection. 1825.12-10.4

58. Lid of a box
Height 19 cm; thickness 13 cm;
basalt
St. 372

59. Fragments of a box, possibly the cinerary casket of Ahuitzotl
Height 23 cm; Width 34.5 cm;
Ex. Brasseur de Bourbourg
Collection. Q82 Am. 860

Bibliography

AGUILERA, C. 1977 *El Arte Oficial Tenochca*, Universidad Nacional Autónoma de México.

BRAY, W. 1968 *Everyday Life of the Aztecs*, B. T. Batsford Ltd. London.

CORTÉS, H. 1971 *Letters from Mexico*, translated and edited by A. R. Pagden, Orion Press, New York.

COVARRUBIAS, M. 1957 *Indian Art of Mexico and Central America*, Knopf, New York.

DAVIES, N. 1977 *The Aztecs*, Abacus, London.

DÍAZ DEL CASTILLO, B. 1969 *Historia de la conquista de la Nueva España*, Editorial Porrúa S.A., México.

DURÁN, D. 1967 *Historia de Las Indias de Nueva España e Islas de la Tierra Firme*, 2 vols, ed. Porrúa S.A., México.

DURÁN, D. 1971 *Book of the Gods and Rites and The Ancient Calendar*, translated and edited by F. Horcasitas and D. Heyden, University of Oklahoma Press, Norman, Oklahoma.

KUBLER, G. 1962 *The Art and Architecture of Ancient America*, Pelican History of Art, Baltimore, Maryland.

LEÓN-PORTILLA, M. 1963 *Aztec Thought and Culture*, University of Oklahoma Press, Norman, Oklahoma.

LEÓN-PORTILLA, M. 1972 *Visión de los Vencidos. Relaciones Indígenas de la Conquista*, Universidad Nacional Autónoma de México, México.

NICHOLSON, H. B. 1971 'Major Sculpture in Pre-Hispanic Central Mexico', *Handbook of Middle American Indians*, ed. R. Wauchope, v.10, pp.92-134, University of Texas Press, Austin, Texas.

NICHOLSON, H. B. 1971 'Religion in Pre-Hispanic Central Mexico', *Handbook of Middle American Indians*, ed. R. Wauchope, v.10, pp.395-446, University of Texas Press, Austin, Texas.

PORTER WEAVER, M. 1981 *The Aztecs, Maya and Their Predecessors*, Academic Press, London.

SAHAGÚN, B. DE 1950-71 *Florentine Codex: General History of the Things of New Spain*, translated from the Nahuatl by A. J. O. Anderson and C. E. Dibble, 13 vols, Monographs of the School of American Research, Santa Fe, New Mexico.

SAHAGÚN, B. DE *Historia General de las Cosas de Nueva España*, translated from the Nahuatl by Angel María Garibay K., 4 vols, ed. Porrúa, S.A. México.

SOUSTELLE, J. 1970 *Daily Life of the Aztecs*, translated by P. O'Brian, Stanford University Press, Stanford, California.

VAILLANT, G. C. 1972 *Aztecs of Mexico*, Penguin Books Ltd, Harmondsworth, Middlesex, England.